Magnificent Derelicts

Magnificent Derelicts

A Celebration of Older Buildings

Ronald Woodall

J.J. Douglas Ltd.
Vancouver, B.C.

75 76 77 78 79 5 4 3 2 1

J.J. Douglas Ltd.
1875 Welch Street
North Vancouver, British Columbia

Printed and bound in Canada

Canadian Shared Cataloguing in Publication Data

Woodall, Ronald.
 Magnificent derelicts : a celebration of
older buildings

 Includes index.
 1. Buildings in art. 2. Buildings. I.
Title.
ND 1410.W66 758.7
ISBN 0-88894-082-3

I am fortunate to be married to a lady who will forego Honolulu and Banff for Wolf Point, Montana, and Druid, Saskatchewan, and to have two small children who will quietly endure marathon distances in the back of a van.

So for all those hours of waiting around the barnyards, this book is for Heather, Jamie, and Adam.

The Paintings

Introduction

This is a book about old rural buildings. It is not about historical landmarks or architectural masterpieces, but rather it is a fond appreciation of some of the debris of progress as seen through the eyes of a hopeless romantic.

It has always seemed to me that the introductions to books are full of excuses. Here are mine. This book does not really deal with history, sociology or architecture; it is more emotional than intellectual; it but scratches the surface of a subject which is diverse and inexhaustible, and the opinions and feelings expressed will crumble in the face of economic logic and contemporary priorities. It is little more than the sharing of a private obsession.

In a way, it is a quiet crusade, a missionary appeal for converts and a confirmation to the converted. Hopefully, at the very least, it is an introduction to a fresh and rewarding new source of pleasure.

There is nothing unusual about liking old buildings. It is true that there are some people who see them as costly eyesores to be destroyed as quickly as possible, but most casual observers are sensitive enough to feel an aesthetic rightness about aging architecture.

There is a kind of comfort to be found in the past and in things that are old. Perhaps it is a rejection of the present or, for that matter, the future. The past is documented and accepted. Its artifacts do not force us to make many judgments, nor do they force us to put our taste to the test. The functional objects of one era seem to become the art objects of the next.

Artists and photographers and filmmakers feature old buildings with such regularity that they have become an artistic cliché. The weathered, swayback barns, the crumbling stone gristmills, the

lonely Gothic farmhouses, and the empty, abandoned churches continue to appear with monotonous regularity on calendars and greeting cards and in magazine illustrations and automobile advertisements. They are used for film locations and television backgrounds. Paintings of old buildings are best-sellers at those little art galleries that cater to popular tastes, and reproductions of them dominate the framing sections of large department stores. But we do not seem to tire of them: somehow, these old and often useless buildings have a mystical appeal to a society committed to newness and progress and efficiency. It is ironic that so pleasurable a legacy should be allowed to vanish at so alarming a rate and with so little protest. If one believes that the senses and the soul must also be nourished, then this is surely akin to ecological disaster, resource depletion and the wholesale extinction of wildlife. At the very least, it is a crying bloody shame.

But, one might argue, buildings *are* being saved. Historical groups and restoration societies are, with great dedication, preserving our architectural heritage for posterity. But they only save the great stone forts and the trading posts and the seigneuries and the government houses and the grand mansions of the very rich and the birthplaces of the very famous.

In the meantime, entire species of buildings, like rare birds, are quietly succumbing to extinction. The country general store, the blacksmith shop and the one-room schoolhouse are disappearing. The homes and barns of the not-so-very-famous will soon collapse under the weight of a heavy snowfall. In some isolated mining town, another street of false front stores will be washed away in a sudden spring flood. A hotel will burn. An old wooden fire hall will have its tower stripped to line the walls of someone's den. The iron balls and the bulldozers will relentlessly continue to take their toll.

One day, nothing will remain but the museum pieces. They will wear fresh coats of paint and have new shakes on the roof. The window mullions will have been replaced and the stone chimney will have been carefully dismantled and rebuilt with new mortar. The original will be indistinguishable from the facsimile. You will not be able to touch the past, but you will walk the landscaped grounds and read the brass dedication plaques and do so under supervision, from nine until five, during the summer months.

How can anyone object to that? Restoration is essential if we are to save anything. But there is, for me, something disturbing about restorations: they are invariably overmanicured and cosmetically retouched. They are embalmed buildings.

Roped-off and repainted pioneer towns with fake gold rush signs and freshly built wooden sidewalks have too often left me with the impression of walking around a movie set. In fact, I have been on movie sets that felt more real than some of the West's most ambitious restorations. I have visited assembled villages where scattered country buildings have been moved to a single location in an attempt to simulate a pioneer town. There is one in Fort Steele, British Columbia; another in Calgary's Heritage Park; others at North Battleford, Saskatchewan; Madison, South Dakota; Bakersfield, California; Salt Lake City, Utah; Fairplay, Colorado; and Phoenix, Arizona. In the East, there are dozens more, but they seem to have that uncomfortable artificiality that is reminiscent of Frontier Town in Disneyland.

I grant one exception: the town of Bodie, California. High on the southern slopes of the Sweetwater Mountain range, it is accessible, but difficult to reach. Its remoteness and the dryness of the mountain air have kept Bodie relatively intact. The California government has turned Bodie into a state park and introduced the concept of "arrested decay." They have moved nothing and changed nothing, including the contents of the buildings. The debris lies where it was

dropped. Maintenance is held to that level which is required to keep the buildings structurally sound and is virtually imperceptible. There is a maximum of protection and a minimum of tampering. In Bodie, you touch the past: the ghosts have not been scared away.

I reiterate that I have no quarrel with restorations; they are necessary and noble undertakings. In fact, they are a nation's obligation to its past. Still, it is regrettable that restorations usually destroy the very qualities which make old buildings endearing to so many people.

What a dilemma. If you restore, you will probably lose the character of the building. If you do not restore, you will lose the building itself. It was the contemplation of this dilemma which led me to my preoccupation with country buildings.

Aging architecture divides into two categories: the few Savables and the many, many Unsavables. Confident that there is a growing and often well-funded movement protecting the former, I concentrate my efforts on preserving the Unsavables in the only practical way open to me — pictorially. This I do with a great sense of urgency because of their alarming attrition rate.

Country buildings have several deadly enemies of which time and the elements, combined with neglect, are the most devastating. Heavy snowfalls, blizzards, windstorms, floods, washouts, falling trees, erosion, and a variety of other natural forces are constantly erasing the frail work of man. Economics is another enemy as buildings become unprofitable and taxes soar. Safety standards demand further heavy investment and a building must pay its way. Fashion is fleeting and suddenly, a building is out of style and obsolete. Ironically, a growing market for things old has made many fine structures the targets for collectors and antique dealers who strip them of ornament and contents. Abandoned farmhouses that were once intriguing storehouses of memorabilia are reduced to gutted,

vacant frames. The rich surfaces of weathered wood and old brick have made these buildings the quarry of contractors and scrap dealers. It is seldom necessary to pay for demolition. It is now the demolisher who gladly pays for the opportunity to destroy.

Progress, so called, and energy requirements are not the allies of aging architecture. In the mountains, a single hydroelectric project can leave a score of communities at the bottom of a man-made lake.

Fires, natural, careless and deliberate, take an astonishing toll. In the ten years that I have lived in British Columbia, a half dozen of the province's finest original country inns have burned to the ground. There is, in some areas, a "scorched earth" policy to burn buildings and communities upon abandonment.

Then there are the vandals and the thieves. It is inconceivable to me that people would go to so much effort to disfigure property not their own. But they do. The snowmobile allows them a long winter to ravage unprotected buildings at their leisure. Vandalism of country architecture in western North America is a horror story.

Too often, the most regrettable fate of all is for a building to be "saved." How distressing it is to see a well-meaning owner mar the natural, functional lines of a finely crafted building with totally unsympathetic remodelling. I have seen graceful balconies stripped from historic old stage stops; hand-hewn timbers covered with artificial brick; asbestos shingling and plastic-topped carports and plywood sheds added to architectural masterworks. It is, of course, the owner's property to do with as he pleases, but what a shame considering that appropriate renovation often costs little more than tasteless tampering.

So, in one way or another, buildings and entire towns are vanishing,

and their like will not be seen again. The loss of one fine building does not seem to matter greatly, but for anyone who cherishes the past, the wholesale destruction is alarming.

Recently, I stood on a street in Vancouver's old West End and watched a bulldozer make rubble of a spectacular Victorian gingerbread mansion. It was absorbing, in a masochistic sort of way, to watch this irreplaceable masterpiece be crushed and mangled and chewed into splintered scrap. The full impact of the spectacle did not strike me until I watched the sorry pile of trash being trucked away while the bulldozer neatly plowed the lot flat.

Suddenly, there was nothing there. All evidence had been removed. It was difficult to understand how something built with so much love and care could, under any circumstances, be destroyed in so matter-of-fact a manner. There was no wake and no funeral. There was no protest and no mourning. There was no reaction and no one to react. This is truly the age of discard. Little that is not profitable is sacrosanct.

While this sort of experience is always frustrating and saddening, I have ceased to be angry or bitter. For the sake of my own peace of mind, I have become philosophical and virtually passive. It is so exhausting to argue about economics and progress and priorities and to be inundated with explanations of efficient land use and life-cycle costing.

So I ignore the cities. They are, for me, unmanageable places that become more nightmarish daily. What is more, they are full of demolition companies who, given the opportunity, would level the Acropolis.

Some day, the cities will choke themselves and one by one have grinding, groaning seizures like overpowered engines that have run out of oil.

Once, in vain, I had hoped that the countryside would be spared the ills that have made the cities so disenchanting. Pop culture is strangely intrusive and much uglier in rural areas, but it is well marketed and spreading quickly. Soon, there will be no place to hide.

It is time for a confession. I have never lived in the country, nor, for that matter, in any place with fewer than a million people. While that fact may explain my disdain for the city, and romanticism for the country, I am nevertheless free of nostalgia and boyhood memories of country living. What I do know about the countryside is that I never become tense there. It is comforting and relaxing, and life progresses at a sensible pace. I buy clothes in small rural general stores simply because I am spared the anxiety of overchoice.

Some day, I may move to the country and find out if it is as good a place to live as it feels on my building hunting forays.

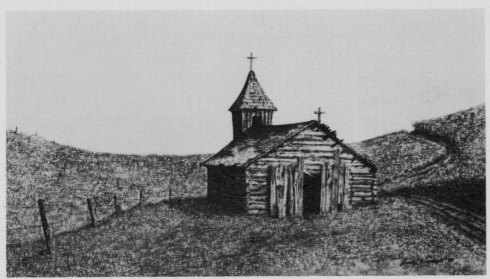

Tahltan, British Columbia

Having established that the countryside and, more specifically, old buildings in the countryside are preoccupations of mine, I should try to explain why.

Most urbanites find old weathered buildings to be at least agreeable and visually pleasing, perhaps because they provide some sense of security and simplification and a touch with one's roots. But for me, these buildings have qualities which transcend all of that. They seem mystical and magical. They bewitch and transfix me, and my affection for them has evolved into an obsession not unlike a religious fervor.

To this day, I am not quite sure how or why this happened, but each year, more and more of my time, money and effort is invested in the search for more buildings. And the more I travel, the greater the expectation becomes. I cover tens of thousands of miles, always believing that somewhere out there, perhaps over the next hill, perhaps around the next bend, perhaps down the third grid road, will be the perfect derelict.

Lately, I think of little else and seem to have lost most other interests. While it is difficult to remember what I did yesterday morning, I have a mental picture bank that provides me with total recall of thousands of buildings in their settings from Alaska to the Mexican border. When returning to an area years later, I can create a vivid mental preview of the architecture and can instantly recall those structures which have vanished in the interim.

It is all quite silly and downright abnormal, and while I cannot explain this questionable use of brain cells, it seems at least as worthwhile as memorizing baseball statistics.

Though I realize that this passion for old buildings is unusual in its intensity, I find it surprising that it is shared by relatively few people. Furthermore, it is quite astonishing to me that there are so many people who do not understand it at all. Why, they ask, would anyone want to go to so much trouble and waste so much film recording such dumps?

How do you answer a question like that? It is not easy. Usually, I try to explain that these buildings are lasting monuments to laughter and grief and childbirth and death and all the best and the worst of times. They are often all that remain of a family, a childhood, a lifetime. The people have gone, forever. They have scattered and perhaps died. Their furnishings, their clothing, their animals and their automobiles have also vanished. But the old homestead, the barns and the stables, the stores on Main Street where they shopped, the mill down by the river where they worked, the church where they worshipped, the little school where they grew up, all stay, at least for a while. And when these go, the last physical evidence of a lifetime goes, and then there is nothing left to remember, like a grave without a stone.

These buildings are beautiful, too. They are not beautiful simply because they are old and weathered and picturesque and quaint. Their beauty goes deeper than that. They are beautiful because they embody the spirit and the essence of a noble and resourceful lifestyle. There is intrinsic beauty in functional simplicity. There is a beauty in craftsmanship that outlasts the craftsman. There is beauty in timelessness.

Even the ugly ones are beautiful. Take a good look at some old canneries and linseed mills and rodeo chutes and hop dryers and roundhouses and breweries and water towers and brick kilns. Take a very good look at them. They are honest, gutsy structures and they will soon be gone forever.

Any attempt at defining beauty will inevitably back me into a mire of contradictions. Cite functional simplicity and I suddenly remember all the marvellous rococco-gingerbread-carpenter-Gothic masterpieces. Talk about craftsmanship and I may be forgetting some wonky and bizarre woodbutcher's creation that took my breath away. There are no inclusive definitions except, perhaps, one.

These buildings are the last of the great folk art objects. Most of them had no architects, no planners and no decorators. They were built by simple people with simple tools for simple, functional purposes. They were very personal undertakings, and the result was high folk sculpture.

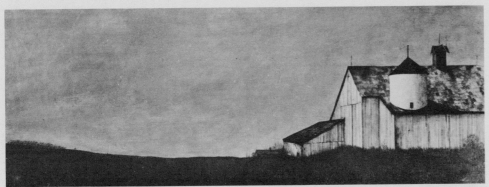

Near Swift Current, Saskatchewan

It seems unlikely that contemporary architecture will age as gracefully as did the older buildings. Construction is no longer folk art. Not even in the country. We are in an age of specialization and we must leave building to the professionals. There is seldom time, money or reason to undertake the planning and construction of one's home or place of business. Somehow, individuality and personality have disappeared from architecture. Whimsy and random decision-making have become expensive indulgences.

People live and work in buildings which are not extensions of themselves but rather the efficient concepts of specialists. At best, we hire an architect who, subject to endless bureaucratic restrictions, attempts to interpret our personal tastes. At worst, we cruise row after row of cookie-cutter tract houses attempting to select the one which is closest to our liking or most distant from our disliking.

Some years ago, I lived on a street of duplexes with so little individuality that a neighbor once ran into our house and settled himself comfortably on the toilet before he realized that he was not in his own home.

Old rural buildings are always different from the one next door. This is remarkable considering the lack of mobility and relative insularity of the early settlers, but after a decade of collecting, I have not found two quite alike. Because they were built to satisfy well-defined individual tastes, there are as many variations as there were people wielding hammers. Through naive planning or human

whim or natural accident, each has become one of a kind. But what has really made each building unique is the aging process. The seasons and the generations have added their own embellishments. A heavy snowfall collapses a roof and it is replaced, differently. A lean-to is added. Red paint covers white paint which covers brown stain and finally, the sun strips them all. The land sinks and the beams bend and a tired silo leans in for support. A door lock ceases to function and another is installed above it. A new window is cut into an unbroken wall. A farmer carefully letters his name on a freshly painted timber and then nature sets to work erasing it. A feed sign becomes a rectangle of rust. These are the scars and the shaping of time. They are all different and all poetically appropriate. They are like the faces of old men.

Today's buildings will not age gracefully because aluminum and acrylic and fiberglass and vinyl and plastic and stainless steel do not age at all. They simply become dirtier and seedier.

The new architectural efficiencies seem to me to lack warmth and charm. Nowhere is this more noticeable than in the countryside and in the rural communities. The traditional board and batten church with the slender white spire has been replaced by a concrete A-frame. The hand-hewn log barn has been replaced by a cold and garish franchised motel operation. Main street has been replaced by the shopping center. And the beautiful, gabled, vernacular farmhouse has been replaced by the ugliest of all man's achievements, the mobile home.

There are, to be sure, complex and perfectly logical economic and sociological reasons for all these changes. But can anyone possibly like these buildings? Does anyone even notice them? Or do we merely tolerate the new constructions because they are expeditiously and cheaply built? They may get us through the week with a little less fuss, but they are joyless. They do little to raise the spirits and are just so many more contributing factors in our headlong rush to a dehumanized future.

You can bet that a hundred years from now, you will not see anyone packing up oils and canvas to spend a day painting a century-old supermarket. It will never look any better than it does right now.

Quite often, I have noticed that when a farm is sold for subdivision, the old buildings are left as a kind of focal point. They become a theme element, and the real estate people give the development a rustic name like Meadowbrook Farm or Old Homestead Acres. Invariably, they are the most attractive and dignified buildings on the tract, and would probably fetch the highest price had they not been reserved for the developers' own use.

This is remarkable if only because they were probably hand-built by a man whose business was not construction or architecture, but farming. Furthermore, they were built by a man whose skills were not acquired in a technical school or university, but were handed down from generation to generation. It seems to me a minor miracle that these early builders were such fine designers and craftsmen. Perhaps the answer lies in their intent. They built for soundness and endurance. They were not preoccupied with trying to "price it right" or with finding a formula for quick marketability. They worked simply, diligently and resourcefully. They built their buildings to complement an honest and basic and noble life-style, and in their innocence, they produced masterpieces.

Now, having gone on at length about craftsmanship and essential rightness, I must add a final requisite. It is what, for me, makes a good building great, and a great building grand. It is the most important quality of all.

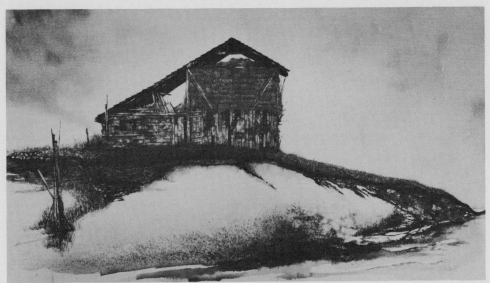

Near Grindrod, British Columbia

A building must be one with the land and have surrendered to the elements. It must not be an intruder on the landscape, but rather it must be part of the landscape. It must have fused with the earth, capitulated to the wind, bent and bowed with the snows and camouflaged itself in a coating of age. It must be gaunt and dry-boned like a great ghost galleon sinking into a grassy sea. It must hold secrets and mysteries. It must be bizarre. It must be elegant. It must be chilling. It must be enchanting. It must be entrancing.

This is the grand, magnificent derelict. That haunted artifact, crouching in the high grass, forsaken, its gray planking sandblasted to a fine patina, its patchwork roof yielding to moss and rot and collapse, its black window eyes staring bleakly into nowhere, resigned, dust returning to dust, doomed and without hope of reprieve.

Here is a paradox. While it is depressing to see old buildings crumbling and rotting into extinction, I cannot deny that it is the neglect and abandonment which convert them into artistic subject matter. In the excitement of discovery, I often forget that these places are

21

the debris of failure and heartbreak and sorrow beyond imagination. I tend to linger in towns and on farms where there are more dead people than live ones. Where there are empty streets and full cemeteries. I have become a scavenger, a bone-picker, an architectural necrophiliac.

There is no way to reconcile a plea for preservation with a painter's eye for the aesthetics of decay. That is why I like to go to Bodie.

It is not a simple matter to find the great buildings and it is almost impossible to find the grand ones. The buildings of the mind are quite different from those beyond the next rise. I have invested days crisscrossing the grid roads of northern Saskatchewan, tracking the last of the great sod homesteads, only to find them long ago plowed into the earth. I have driven from dawn until dusk to discover that Sundance, Wyoming, is a strip of motels. Two days of fruitless search for a Hutterite ruin left me mired to the axles in Manitoba gumbo mud.

It is not even safe. I have been stalked by fanged family pets the size of timber wolves. I have had twelve-gauge shotguns leveled at my head. I have come face to face with an agitated bull in a dark barn stall. I have spent tense hours alone in a deserted mountain ghost town with a jeep load of pistol-toting rednecks who showed an abnormal interest in my camera equipment.

There have been great days and terrible days. It is a little bit like prospecting. There is a treasure up that road, nothing down this one. Which to choose? Much of the fun is in the hunt.

For every disappointment, there is an elation. An ill-chosen short-cut in California led me to a stone hop barn, an heroic structure not unlike a medieval fortress. One midnight, out of gas in central Alberta, I awakened a garage owner and talked through the night. The next morning, I was led to a fanciful and bizarre carousel barn fraught with mystery, and was regaled with hushed tales of murder and deeds most foul. A temporary loss of direction in the central prairies detoured me to the last of the abandoned Doukhobor villages. It was dominated by a great three-story mansion of mesh and mud stucco over hand-hewn logs. A purchase of ice cream cones at Dog Creek, British Columbia, led to a conversation in which the keeper of the general store divulged the location of a century-old flour mill hidden in the forest and a completely abandoned but intact Indian village on a nearby mountain plateau. A two-mile detour north of Yorkton, Saskatchewan, to photograph a pretty but unremarkable onion-domed Ukrainian church resulted in a conversation with the groundskeeper, who told me that an extra mile of detour would take me to the building it replaced, an apparition straight out of Dr. Zhivago.

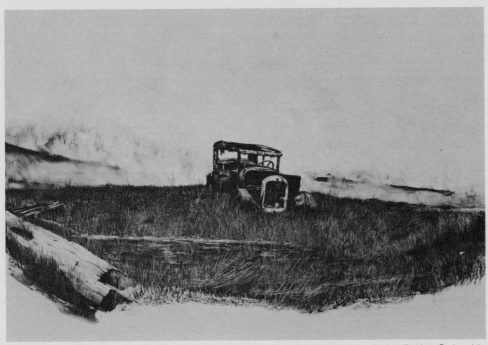

Near Douglas Lake, British Columbia

Hopefully, the fact that there are intriguing discoveries hidden across the countryside has whetted your curiosity enough that you will think about trying some building hunting on your own. After all, the more of us collecting, the more old buildings will be recorded before they are lost.

First, you will have to get to the country, and this, as cities spread like giant irrepressible fungi, becomes a little more difficult each year. The countryside has become an urban hobby, a speculative investment, and a place to "develop." What a lovely euphemism to describe the utter desecration of farmland without regard for either aesthetics or intelligent use of the terrain. Land "developers" are worse than mere quick-buck artists, and someday we will regret what they have been allowed to do.

Happily, there is still a lot of country left, and we should enjoy it

while it lasts. For every acre lost to the land hustlers, there are hundreds, maybe thousands left to explore. The western countryside is so big and the distances are so great that there is a lifetime of building collecting ahead of us.

I have calculated, for example, that if I lived to be eighty years old and explored three hundred miles every day of every year, ignoring all of the grid roads and logging trails and cowpaths and field ruts that lead to god-knows-where, I still could not cover the back roads of rural North America. This is distressing but comforting because, while it is impossible to find all of the buildings, I will never run out of places to look.

The collecting of old buildings can become for you, as it has for me, a totally absorbing pastime. Give it a try and, at the very least, I can guarantee that you will rediscover the pleasure of driving your car.

This is the age of the automobile. The landscape is disfigured by a maze of asphalt scars. Cities seem designed not for people but for motor vehicles. The car has cost us dearly in peace and quiet. We hurtle from point to point on high speed turnpikes, always a split second removed from violent death, simply because for many of us, driving has become so harrowing an experience that we wish to do as little of it as we can.

But for all that is wrong with the automobile, it still provides us with the quickest and easiest escape from the chaos it created. You must get out of the cities and off the highways, for they were designed for speed and efficiency. Pleasure and discovery were low priorities. So pick your spot, turn right or turn left, and then drive as far as you can. Tuck your maps under your seat. Be curious. Meander. Every road will go somewhere. There is no such thing as getting lost.

There is out there, behind all those strips of motels and billboards and gas stations, an unspoiled pastoral tranquility that has remained virtually unchanged for generations. It is one of the last free pleasures, and is yours to enjoy.

The imperfect art of building collecting forces you to seek out the most remote and bypassed areas, because that is where the buildings are. Each side road which has never held any interest for you and each dead and dying little town that you never bothered to visit can now be explored with new interest and in the hopeful anticipation of discovering a treasure.

You will not be searching for the historic sites and landmarks or the restorations advertised in the travel folders. That sort of activity is called Tourism. You get to those places on wide, paved highways by following the signs, and so do millions of others.

In the collecting of old buildings, the real pleasure and rewards are found in the exhilaration of making your own discoveries. For this, there are no guidebooks and no maps, but there are some tricks. A general knowledge of an area's history, an application of some common sense, and a little bit of sharp instinct will usually yield results. As a general rule, the oldest settlements are the richest in buildings. Usually, they predated the roads and were therefore reached by water. Rivers, deltas and protected inlets are promising places in which to begin your hunt. Be sure to check for hydro-electric projects before traveling any long distances, because a dam will almost certainly have flooded the upriver towns, and even those indicated on the maps will likely be relocations of the population but not the buildings of the old river-front communities.

Inland, the railway came through before the roads. As the railway

was the only supply source for the opening of the West, almost all of the original settlements were built around the depots. A little research into railway history and a few maps of the complex turn-of-the-century rail systems will give you a good indication of where to find once-active areas that have been since bypassed. There are hundreds of railway ghost towns. The farmers traded their buggies for motorcars and it became a simple matter to drive to the larger town for the weekly shopping. Soon, there was no longer much need for the trains to stop every seven or eight miles, so the tiny communities between the major depots stopped growing. They became obsolete and were often abandoned. The prairies are strewn with such towns and they are a building hunter's bonanza.

The major highways tend to offer far less than one might expect. Even though they often follow the routes of historic trails, the corridors through which major highways run become prosperous and commercially valuable. The towns along major highways tend to maximize land use by eliminating the old. They become little more than modern trade and distribution centers for the outlying areas and all-purpose comfort stations for the traveling public. These towns have undergone drastic visual changes, too. No matter how historically rich they may have been, they invariably become plastic white ways of motels, hamburger stands and garages.

On the Trans-Canada Highway, a little way up the Fraser Canyon, there is a sign informing the traveler that he is entering "the Historic Town of Yale, British Columbia." I can remember the excitement with which I first turned off the highway into Yale. After all, Yale was the final inland port for the steamships which brought the Cariboo goldseekers into the interior. From Yale, they embarked on the torturous Cariboo Wagon Road to the north. I recalled archival photographs of the teeming metropolis, its docks lined with massive sternwheelers. Yale was the last touch with civilization for the fortune-crazed. At Yale, thousands worked the gold-laden sandbars of the Fraser River. From Yale, the stages and the great freight wagons rumbled northward to the glory holes and returned with millions in pay dirt. Wide-open, rip-roaring, hard-drinking Yale!

Imagine my disbelief at what I found in Yale. There was an 1860 church called St. John the Divine. It was well restored and maintained. That was all that remained of gold-rush Yale. The rest was gone without a trace. Today, Yale is a good place to get a hot dog or have your tires checked, but if you want to experience anything of its history, you will have to read about it.

The same is true of too many highway towns. Stay off the highways because they are usually a waste of time. Head instead for those areas between the main routes. Avoid roads that join cities. Look for those that follow the terrain, and twist and turn through the valleys and over the hills. Look for old asphalt. Look for dirt. Look for places where the grass still grows between the tire tracks.

Traveling into the backcountry is like passing through a twilight zone into another era. It is fascinating the way something magical happens. Time comes to a stop and somehow, you instinctively sense it. A little shiver, perhaps. A feeling of déjà vu. A calm and an exaltation at once. When it happens, the time has come to abandon your car for a while. There is good reason to go on foot. You are a stranger where strangers are rare, and often suspect. There is nothing more suspicious than unidentified people staring from an idling automobile. So get out of your car. Do not be shy. Talk to someone. It is comforting and, at first, surprising to discover how friendly and helpful and informative country people can be.

When I started hunting buildings, I usually felt like an intruder. Wary faces peered from behind pulled curtains, and no wonder! I was either aiming a telephoto through my car window or standing uninvited in someone's cornfield. Then, deciding upon a more direct approach, I began to knock on doors to explain my intentions and to show a sincere appreciation of the buildings and the area. Invariably, I was rewarded with the run of the property, an expert guide and, as often as not, an invitation to tea.

Quite naturally, the local inhabitants are the best source of directions, updated information and priceless trivia. If you really want to learn about an area quickly, talk to the local newspaper editor, the people who run the general store, the postmaster, the men who work at the grain elevator, the fuel oil delivery man, the local policeman, and the staff at the town hall. The rare and remarkable people you befriend will be half the fun of your building hunting ventures. If you take the time to talk and listen, show honest interest and ask the right questions, you will usually depart armed with a treasure map of the area. If you make a new friend at every stop, fresh leads will multiply like compound interest. You will be sent across fields and up private roads and past warning signs that you would not otherwise have dared to challenge. Your new friends will phone ahead, arrange a welcome and have the dogs called off for your arrival.

There is a vast difference between finding a building and experiencing it. Your memory will be much more rewarded if you have walked around a building and through it, smelled it and heard the sounds it makes in the wind. It is important to have seen what is in a building and what is lying about it and how it looks from every angle and direction; to have met the people who own it and, as often as not, who built it; to enjoy the homespun history lesson they have given you. In short, it is always worth the trouble to say hello.

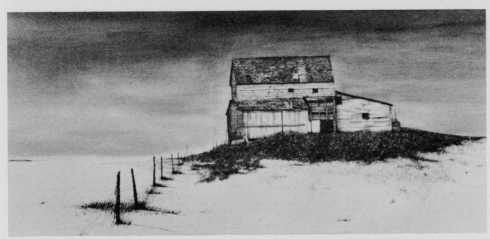

Near Glenwood, Alberta

For most people, it is probably quite enough to drive around and look at buildings, but I feel compelled to bring every one of them back with me. So when I talk about collecting, what I really mean is photographing — the best way I know to record the great numbers of buildings I find. The degree of photographic sophistication employed is a matter of individual preference, but I like to keep things as simple as possible. I take 35mm color slides, usually with a standard lens. Currently, I use an automatic Pentax ESII which I have found to be virtually foolproof. Being an amateur photographer, I let the little computer in the ESII make all my exposure decisions. There are very few repair shops in the backcountry so I carry a second Pentax just in case. I carry a tripod but only use it when the light is failing. My first rule is that the less there is to carry, the better. If a special problem arises, there is always a boxful of lenses and equipment back in the van.

Having seen some superb photographic interpretations of rural architecture, I know that photography can be a high art form, but for the most part, I use it as a quick and efficient means of record keeping because I cannot quite attain all my objectives with a camera alone.

27

In explaining his work, realist painter Alex Colville said the "photography is taking and painting is making." What a succinct and simple answer to the "why paint?" question! Painting requires a ritualistic investment of time and judgment that forces an intimacy with the subject matter. With painting, there is more control, more involvement, and a chance to give the subject so much more loving. When you photograph a building, you have recorded it, but when you paint it, you understand it.

There are, for me, several other reasons for spending so much time on precise paintings of buildings which I have already collected photographically. These are subjects which, seen in their actual surroundings, seem commonplace and often go unnoticed. In my source photographs, they cry out for embellishment. Their essential qualities have invariably been diminished by a variety of distracting and discordant elements. They have been spoiled by thoughtless and distasteful renovation. They have the wrong landscape, are badly sited, and the terrain detracts from their lines. They demand to be removed from the clutter that has accumulated around them. The telephone wires and billboards and sidewalks and trash heaps and neon signs and all the ugly neighboring structures that have grown up around them are removed in a painting. After all, these buildings are having their portraits done and so, as much as possible, they must be ennobled. Even people and animals are removed. Aloneness is surely one of the greatest and last luxuries in this crowded world. If the viewer is to experience the subject with any degree of heightened intensity, he should be alone with it, and it should be isolated and idealized.

I attempt to elevate the ordinary, and painting gives me the control to fantasize slightly and to inject that light touch of surrealism and idealism, the landscape in my mind. With photography, I must settle for what is there. That is perhaps an oversimplification. It is difficult to write about one's own work and motivations, for painting is very personal. With my work, there is very little to explain. Hopefully, people will look at it and like it. What they see is what it is. I keep trying to improve.

There is a fine line between what is a painting and what is something else that happens to be rendered in paint. Paintings and pictures are not the same thing. The best of the wildlife artists are superbly skilled craftsmen, but because they record a specific category, it seems open to debate whether they are "painters" in the accepted sense. It may be the same with architectural portraits, where composition and technique serve only to best portray the subject. Being more interested in buildings than in painting, I do pictures of buildings. If they are considered paintings, I am delighted. But it really does not matter. I have found my niche.

Deciding which buildings to paint has always been a random process. It involves looking through a stack of source photographs until something strikes my fancy, and then an hour is spent on small felt-pen sketches. I experiment with landscape and color alternatives, size and placement of the building in the picture, elements to be added or eliminated, sky, season, ground cover, light source, and, finally, what might be done to advance or return the subject to that perfect stage of arrested decay. Anyone bothering to compare one of these paintings to the actual site is in for a surprise. While I try to paint the building as faithfully as possible, as I have already said I take liberties with any elements that seem displeasing. The landscape is almost always pure invention and while it is usually kept authentic to the area and the terrain, it is always reshaped and developed solely to isolate and enhance the building.

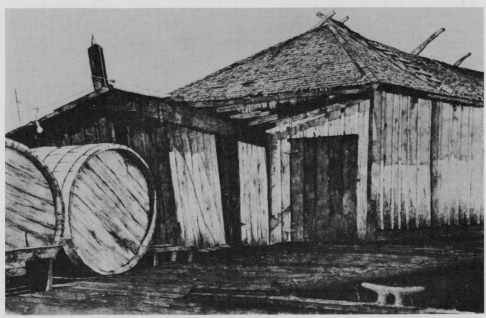
Rivers Inlet, British Columbia

There are about seventy paintings in this book. With each, there is a little story, or perhaps more accurately, a little non-story. These are anonymous buildings which served simple, functional purposes and lived uneventful lives. Initially, these paintings were done simply because I liked the buildings' looks. It was only for this book that I began to delve into the histories of the buildings I had painted. Some, I found, had very interesting stories in their past. Some had no history at all. There were a few which I couldn't even find again! Hopefully, the random way in which these buildings were included will provide an honest cross section of backcountry folklore.

Inquiries into these forlorn and forgotten places often yield delightful surprises. No profound discoveries are made, and history is seldom rewritten; but it is quite moving to stumble across homespun tales of love and joy and hardship and suffering, weighty with suspicion and superstition, country humor and gothic horror, and vivid recollections of hungry years and youthful death. They are

half-remembered, half-forgotten, and probably half-true, but always absorbing and a pleasure to collect.

A farmer is dumbfounded that I would want to write about his barn and his grandfather who built it and the prairie fire that almost destroyed it in the forties. But he is also flattered because no one else has ever bothered to ask. So the floodgates of his memory open wide and he tours me through a lifetime which, in its way, has been colorful and creative and full, and deserves recording. There was a time when I questioned the value of augmenting each painting with a story. The gathering of information is time-consuming and, at first, the stories seemed trivial and irrelevant. But after a few had been published, it was gratifying to learn how many people had been curious about the old buildings and the people who lived in them. Hopefully, these stories make the countryside a little more interesting and pleasurable, and so are worthwhile. At the very least, they are minor tributes that would not have otherwise been written.

Most of the buildings in this book are western, the majority being in my home province of British Columbia, for naturally I first painted the area with which I am most familiar. But in the last few years, my explorations have tended to get farther and farther from home, so that my collecting area now covers a huge rectangle reaching from Manitoba and the Dakotas in the east to the Pacific coast in the west, and from the Yukon and the northern prairies to Arizona and New Mexico in the south.

This affinity for the North American West stems from the fact that it has a quality that is not found anywhere else. I refer to the phenomenon of abandonment. For a variety of reasons, people have simply walked away from their homes and their farms, sometimes

leaving entire towns and cities empty. Across the western plains, the small farmers and ranchers are still packing up and leaving. Some of them sell out to agribusiness, others become "suitcase farmers" and commute to the fields from the security of a serviced community, and some decide that they have grown too old to suffer another winter. So the horizon is strewn with perfectly sound but rapidly deteriorating ghost buildings. In the mountains of British Columbia, there are dozens of Indian villages whose inhabitants can no longer live off the land. The sheltered inlets of the North Pacific coast are dotted with the ruins of rotting cannery towns which have succumbed to winter storms and are quietly vanishing into the sea. In the mountains, there are entire communities like Elkhorn, Montana, and Silver City, Idaho, and Sandon, British Columbia, which are cities with town halls and hotels and rows of stores and telephone poles and sidewalks and fire hydrants, but without citizens. They are deserted.

Up in the hills on the Nevada-California border, the crumbling remains of a three-story stone bank, a massive railway depot and a huge brick school building stare out across Death Valley like giant tombstones. They are the sunbaked remnants of Rhyolite, a city whose population shrank from 12,000 to zero. Rhyolite at its prime had a stock market, an opera house and a symphony orchestra. In 1907, two magazines and four newspapers were published in Rhyolite and the city was serviced by three different railways. By 1922, it was empty.

In south central Saskatchewan, a baronial mansion with a couple of dozen rooms sits alone in open prairie, an anomaly among the grazing livestock. It is solidly masoned of local fieldstone, as are the complex of outbuildings, and the 120-foot stone stables are as finely finished as a gentleman's den. It would cost a million dollars to build

it again, perhaps two million; but it is abandoned. The windows are boarded or vacant. The last of the ornate Victorian gingerbread fretwork dangles precariously from the eaves and from collapsed balconies. The chimneys are crumbling and the roof is full of holes. A wall has fallen away to expose the elegant winding main staircase. This great building is on the verge of collapse and will probably soon vanish forever.

There was, up in the hills behind Greenwood, British Columbia, a metropolis called Phoenix. It had a long main street of big commercial buildings, a dozen hotels and twice as many saloons. It was a sophisticated, wealthy and cosmopolitan city with an artificial ice rink and a professional hockey team good enough to challenge for the world championship. The ore ran out in 1919 and the people left. Today, nothing remains. Phoenix has been plowed back into the earth.

The West is a vast repository of these enigmatic artifacts. It is desolate and lonely and often supernatural. Everywhere, these bizarre and brooding structures, built and abandoned by mysterious and eccentric individualists, have been left to bleach and crumble like dinosaur bones in the sun. It could be that they are the North American equivalent of the great ruins of the ancient world.

These magnificent derelicts are going more quickly than we realize. They step aside for housing tracts. They are dismantled for playroom walls. They are set afire because someone thinks them useless. They cannot be saved. They cannot be refinished like a spinning wheel for some suburban living room. They cannot be towed away for restoration like a vintage car. They cannot justify the space they take, and no law can protect them. So they go. And that, somehow, is sad.

Opposite: Farmhouse near Hill Spring, Alberta, now used for feed storage.

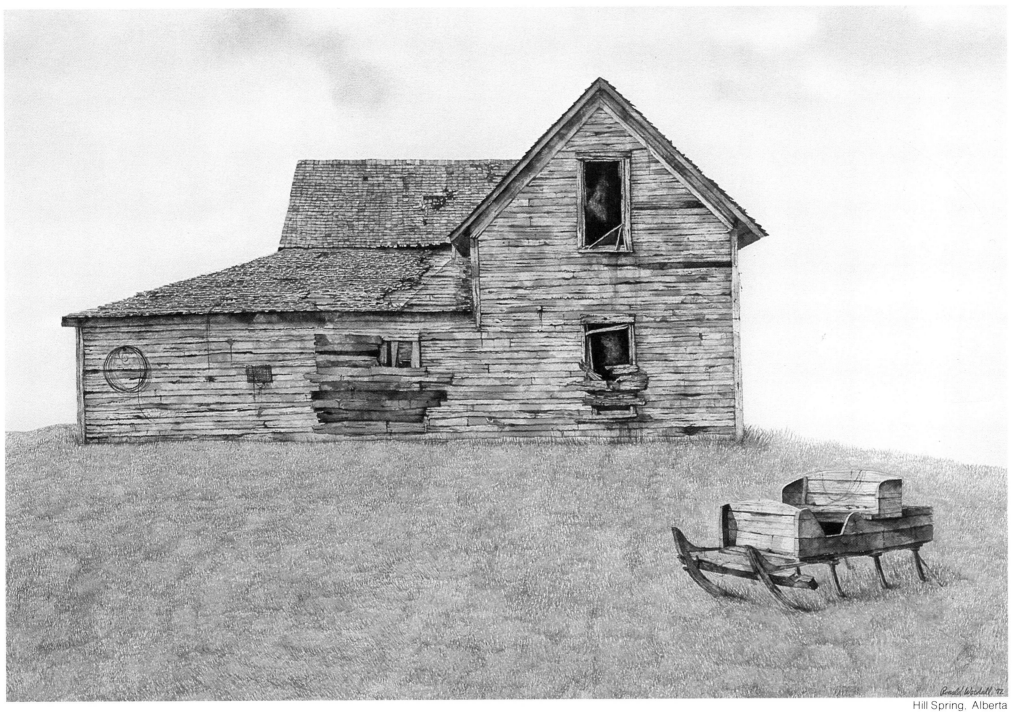

Hill Spring, Alberta

In the 1800s, Harrison Mills was a very active place. It was an important trading, railway and sawmill center, and was the north shore terminus of the Fraser River stern-wheel ferries. Before the road was completed up the Fraser Canyon, the main route north to the Cariboo goldfields started at this bustling community, but by 1915 it had been bypassed completely.

Today, little remains apart from the Acton Kilby Store, the ruins of the Rat Portage mill, and on the Scowlitz Indian land, just east of the townsite, St. Mary's mission church. You reach it through a water-filled tunnel under the railway tracks. It is gaunt and gray and ghostly, almost skeletal. It is taller than most mission churches and the steeple is slender and delicate. For a pioneer building, it is remarkably elegant.

Before venturing inside, we stopped by the general store to talk with Acton Kilby, the patriarch of Harrison Mills. The Kilby store is a balconied, three level, red, white and blue monolithic structure which became a government museum in 1971, ending Harrison Mills' life as a town. Kilby remembered that the church was there when he came to the area just after the turn of the century, and the earliest archives reference is dated 1899.

The Scowlitz Indians are a small band of the Upper Stalo language group of the Coast Salish tribe. They lived on the Harrison mud flats and were never numerous. A 1916 Indian Affairs census reported a band population of thirty-three, although the Indians claimed that they numbered fifty-four. The absentees could have been off fishing or hop picking, but in any case, the Scowlitz were few in number.

That same report, which described the band as "comfortably well to do," noted that the women, fearing health hazards, refused to send their children to the mission school. They were demanding day care in 1916!

Across the road in one of the three remaining dwellings, we met Johnnie William who, at sixty-seven, claims to be the oldest Scowlitz. He recalled the days before the roads when Father Chirouse came by train and slept in the tiny vestry. He showed us his Holy Sacrament of Baptism signed by Father Chirouse, dated May 9, 1908.

We were interested to learn why a church dies. Johnnie told us that about 1955, only a few people were showing up for Mass and sometimes no one. So the priest stopped coming. Shortly afterward, the church suffered a quiet but undignified death. The young people gutted it completely to build a floor hockey rink. They threw the contents — pews, statuary and all — into the nearby bush, much to the delight of treasure hunters and antique dealers.

Inside the empty shell, the nave is painted turquoise with bright blue trim. The wind moans through the Gothic windows, only one of which retains a section of curved mullion and stained glass. The creaking and groaning ceiling is falling, board by board. Sixteen steps lead to the choir balcony and steeple where a pulley bolted to the cross beam is the only equipment remaining in the bell loft. The floor is littered with curved-blade hockey sticks. A chicken wire goal has replaced the altar. The chancel wall is pockmarked from slap shots. Looking around, one would have to conclude that there seems to be more enthusiasm for floor hockey at St. Mary's than there was for Mass.

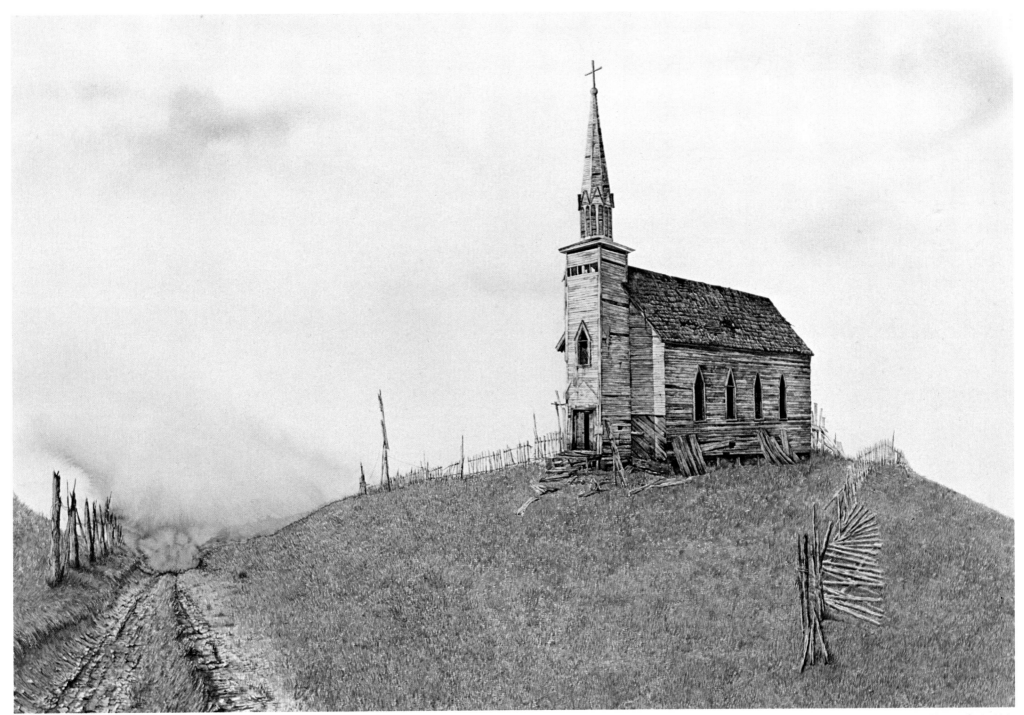

Harrison Mills, British Columbia

Anyone who has skied at Sun Valley, Idaho, has probably passed through the town of Shoshone to the south and perhaps noticed the unusual exterior surface of most of the buildings there. They appear to be made of stone, but have a strange high-contrast black-on-white coloration, rather like animal spotting. They are all constructed of lava blocks cut from the nearby volcanic flows. The blocks are thickly mortared and give the buildings a graphically crisp checkerboard exterior which is quite handsome.

The building in the painting is a slaughterhouse about a mile east of Shoshone on the road to Boise. It was built in 1898 for Fred Hill who ran the butcher shop in Shoshone. The two men hired by Hill for the constuction, carpenter Antone Bragga and a stonemason named Castra, were Portuguese from the island of Peco in the Azores. The wooden tower still contains the huge water tank which was used for cleaning the butchered meat. The water was pumped up from the nearby Little Wood River.

It seems to me that the interiors of abandoned slaughterhouses forever retain a cruelly bizarre quality. Somehow, the chilling reality of the violence and brutality of butchering seem to linger. In this one, the meat rails that transported the bleeding carcasses to the cooler room are still bolted to the ceilings, and it is not difficult to imagine the squealing and bellowing, the hacking and chopping, and the floors running deep in blood and entrails.

Today, the old slaughterhouse has been refined into a gentleman's barn for the family horses of Mr. and Mrs. O. J. Harris. The building has a new cement floor, new roof, and new doors and windows.

The Harris family, cattle raisers from Nampa, Idaho, moved to Shoshone in 1959 and turned the then defunct sales yards into a thriving business. Besides restoring the slaughterhouse, they completely remodelled the derelict 1904 Fred Hill farmhouse, turning it into one of the showplace homes of the area.

Shoshone is a genuine western cattle town, first settled in the late 1870s. The name of the community, like that of the Indian tribe, means in the Shoshone language "the Great Spirit." The town was a hotbed of saloons, gambling, bad whiskey, wild women and gunfights. The railroad was constructed through Shoshone in 1883 and the first passenger train arrived a month later. The discovery nearby of silver and lead deposits caused the town to grow rapidly around the depot.

To this day, the main line of the Union Pacific railroad runs right through the center of town, giving Shoshone the distinction of having the world's widest main street.

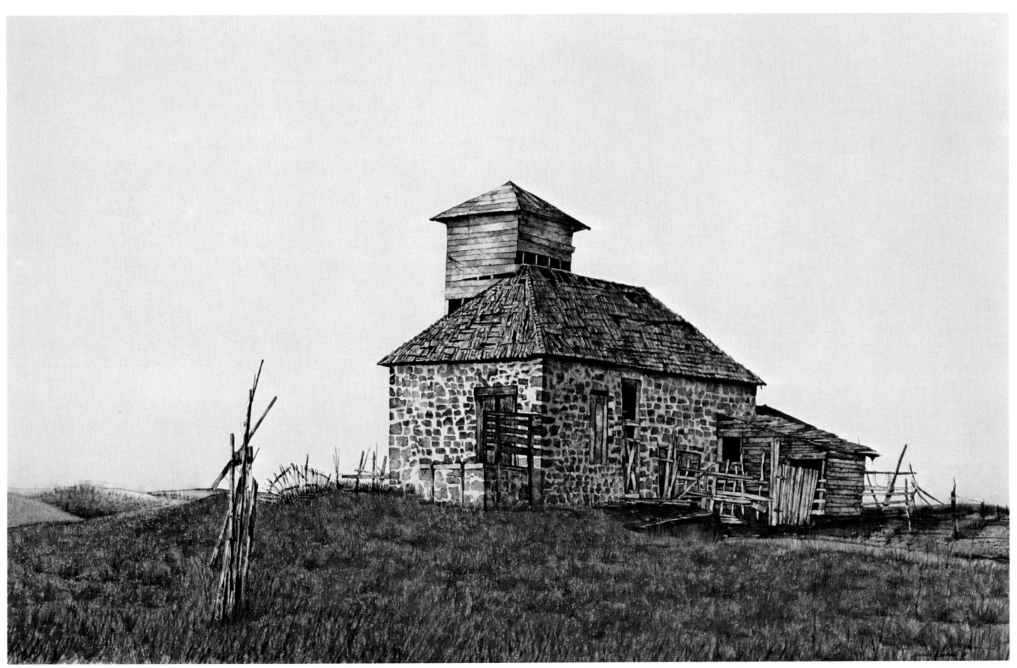

Shoshone, Idaho

These buildings in Duncan made up one of the best Chinatown blocks anywhere in small-town North America. In November 1970, they were demolished to provide parking space for Duncan's city center. The irony is that their destruction was necessary to complete a project for British Columbia's centennial year. There is something quite unprogressive about such progress.

Not too long ago, Duncan's Chinatown covered several city blocks and had a population of 150 which doubled each weekend when the bachelors came in from the logging camps to eat, drink, perhaps smoke a little opium and have a game of fan-tan. Long before the centennial year, the city had chosen the old Chinatown as the site for its civic complex. They began to buy the buildings, and leveled most of them. They built there a cylindrical city hall which is completely out of place in the Cowichan Valley. Finally they acquired these last three buildings. Suey Lem Bing's restaurant and adjoining grocery store was built about 1914. The next building, completed about 1918, housed the Chinese Freemasons and the Dart Coon social club. The far building, also of 1918 vintage, was the Chinese Benevolent Society.

The demolition was not completely unopposed. Jim Quaife, who was mayor in 1970, told me that he and a few councilmen wanted to save the buildings for a west coast Chinese museum. But the city risked losing the centennial grant available for the new library and senior citizens' center if the area was not completely cleared, and the provincial government would not finance the cost of moving them. Furthermore, some influential citizens in Duncan considered them a lingering eyesore. The fifteen elderly Chinese residents, given the prospect of new and comfortable living quarters, had mixed feelings. Wrecking tenders were called. The demolition contract was awarded to a bushy-bearded contractor named Randy Streit. During the three months of work, passersby, particularly the young, commented often on the shameful way that British Columbia destroys its heritage. Streit began to feel almost personally responsible for the demolition. He had an idea. Why not move these buildings and other threatened structures in the area and assemble an historic village? So Whippletree Junction was born.

Beginning with the salvage from Duncan's Chinatown, and the bakery and general store from nearby Cobble Hill, Randy and partner Art Dawe added a blacksmith shop, a livery, a firehall and a street of false fronts. They brought in wagons and tin lizzies and ornate hearses from Quebec and Ontario. They imported a massive saloon bar from the St. Francis Hotel in Butte, Montana. They tracked down authentic furnishings for the barbershop, the dentist's, the toy shop, the general store, and a dozen other buildings. They even found an old-time circus carousel and shipped it from Iowa. All this happened because Duncan's Chinatown died.

One day, over coffee, Randy talked about the demolition. In the attics were stored belongings of tenants who had died years before. The suitcases usually contained tiny cork boots or sneakers, a suit of Sunday clothes, a pair of gloves, shaving gear and a teapot. He gave us one such teapot which we treasure. The bachelor rooms measured six by eight feet and each had a commode, a wood stove and a mattress on planks. A trap door in one building revealed a mysterious tunnel littered with opium bottles. The roof leaked badly, but someone had found a novel way to cope with the problem. There were, Randy swears, at least two hundred buckets hanging from the rafters.

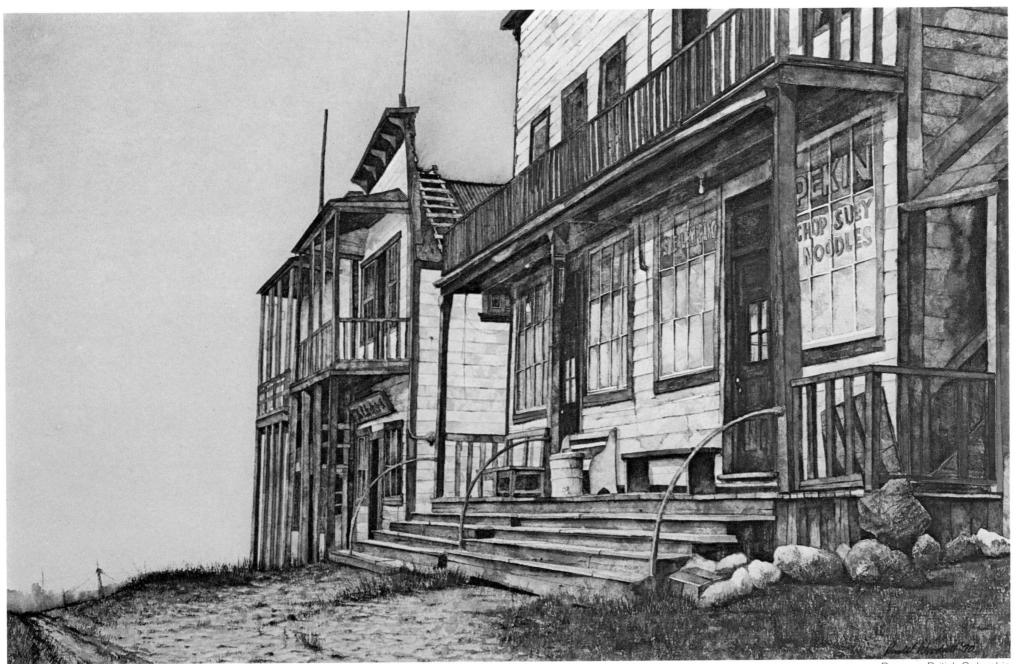

Duncan, British Columbia

The communities and the roadhouses along the old Cariboo wagon trail were usually named according to their distance from the southern embarkation point. This was complicated, as at least three different communities claimed to be Mile Zero at various times.

This old general store stands beside the original wagon road just northeast of 150 Mile House. The store is one of a grouping of historic buildings along the old dirt road at Joe and Peggy Patenaude's 153 Mile Ranch. Originally, these were the buildings of Louis Crosina, an Italian merchant who came to the area in 1900 from Mountain House, where he had operated a trading post. By 1903, he had built a combination store and home, a blacksmith shop, and a log barn. Three years later, he built a second barn for his cattle and a substantial two-story log homestead. All of Crosina's buildings have survived the years, but the most fascinating is the 153 Mile store which he built in 1914.

Crosina's is a gem: the perfect country general store. The name on the sign refers not to Louis, but to Alice Lillian, his spinster daughter who managed the business from 1936 until her death twenty-seven years later. For Lillian, as she was known, the store was her life. She loved to talk and trade stories, and the warm and inviting store became the social center for the scattered trappers, miners and pioneer homesteaders of the area. She spoke fluent Shuswap and had many native friends. She traded supplies for handicrafts. Fine trade goods still line the shelves of the padlocked building.

The interior of the store is like a movie set, with ceiling-high shelves and cabinets behind old-time serving counters. The walls and ceiling are finished in narrow V-joint stripping. At the rear is a small jail-like office with a Victorian safe. Everywhere, there are piles of marvellous, improbable stuff that spans the decades from Early Edwardian through High Flapper to American Graffiti. Lillian saved everything. She never returned unsold merchandise. There are cartons of high button boots and felt derbies and velvet cloches and shirts with snap-on collars. There are coal-fired footwarmers and piles of Collier's magazines and a shelf of Model T parts. The walls are papered with letters, calling cards and memos. The record books go back to the 1880s at Mountain House.

A steep and narrow counterweighted stairway is lowered from the ceiling. The hot, dusty attic is crammed with more treasure: saddles and coffee grinders and Indian buckskin. There are cartons of unopened goods: Pink Arbutus Tar and Freckle Lotion, Quinine Head Rub, and Chamberlain's Remedy, which cures a dreadful ailment called "Bloody Flux."

The basement offers more shelves of rarities, from Tanlac Human System Purifier to Gamble's Horsefoot Remedy. Here, we were struck by the enormity of the two-foot-thick foundation timbers and their precise dovetailing.

Peggy Patenaude, the hospitable ranchlady, knows exactly what she has. The building deserves some restoration and hopefully she'll be able to find the funds. In the meantime, it's in good hands.

She told us a story of Louis Crosina, who was a master blacksmith. His craftsmanship can still be seen in the elegant hardware of the ranch buildings, and his original forge and equipment remain in the 1903 blacksmith shop. When Lillian began to walk, her legs were severely bowed. So Louis fashioned a tiny set of braces for her. Each year, he forged a new set, longer and straighter. By the time she reached her teens, Lillian's legs had been straightened by this combination of artful blacksmithing and home-brewed therapeutics.

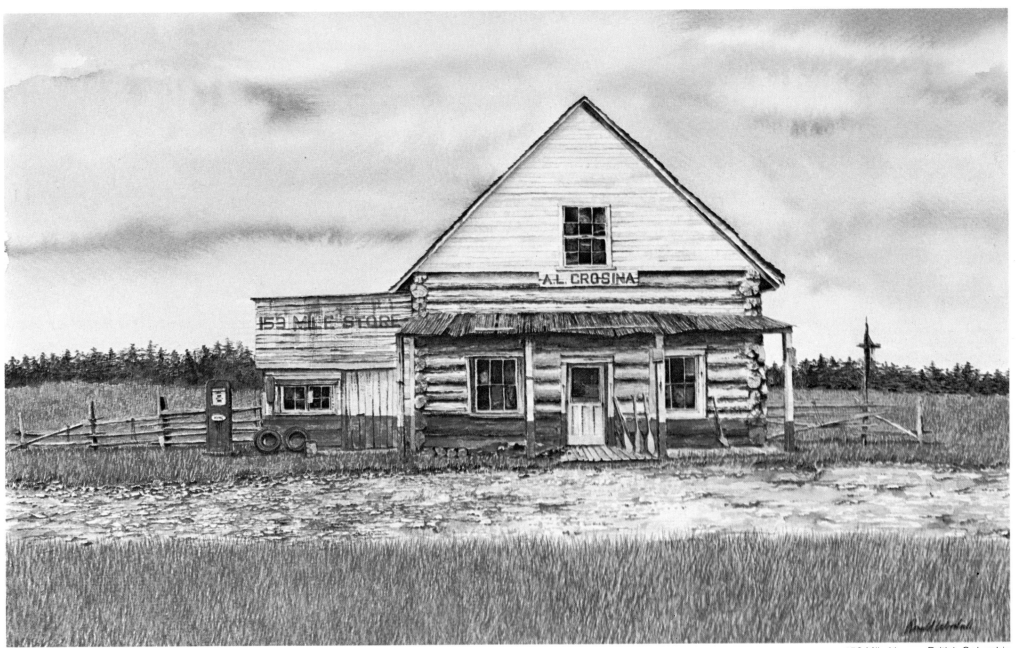

153 Mile House, British Columbia

The last time we drove out along the Old Yale Road, east of Chilliwack in British Columbia's Fraser Valley, we were watching anxiously for a huge and unusual cattle barn near Rosedale which I had painted a few years earlier. Eventually, realizing that we had driven too far, we doubled back, this time looking more carefully. Suddenly, we realized that the lone cement silo and the few skeletal frame timbers that we had passed earlier were the remains of the barn we were searching for. Fifty yards away was the still smoldering embers of what must have been a gigantic bonfire.

We parked the van beside the silo and I went into the old farmhouse to introduce myself to Jean and Norman Stade. We actually knew each other's names because a year earlier, a member of Jean's women's club had requested a signed reproduction of my painting to present to Jean at a banquet held in her honor. How, I asked, could anyone possibly dismantle and burn so spectacular a building? Norm Stade explained that he could not afford to do otherwise. He had sold his dairy cattle twenty years ago, stopped raising beef herds ten years ago, and now leased his land to one of the many Dutch farmers who have moved into the area for crop farming. "Do you know what it costs to replace a roof on a barn that you don't use?" he asked. I don't, but I can guess.

It occurred to me that in addition to snowfalls and windstorms and fire and wood rot and vandalism and barn-wood hunters and a dozen other natural enemies of old farm buildings, inflation had become yet another threat, and we can expect to see barns disappear at an even more accelerated rate in the future.

The Stade barn was so soundly constructed that Norm was unable to weaken it with his big truck and, in frustration, attacked it with his back hoe. It was framed with twelve-inch and ten-inch square adze-hewn posts and beams. The interlocking corner joints were classic examples of the barn builder's craft.

Norman's father, Henry Stade, built the barn between the years 1901 and 1904 and probably designed it himself. It was a strange cross-breed among barns. The main section was a western-style, open-peak, gabled dairy barn. The attached stock and equipment shed had a broken gable roofline into which was built a small Dutch gambrel-roofed granary. Tucked tightly into the three was the surviving cone-topped cement silo. Counting the little hipped cupola, there were five distinctive roof styles on a single barn. Very rare indeed. It was probably the only barn of its kind anywhere. Now it is gone.

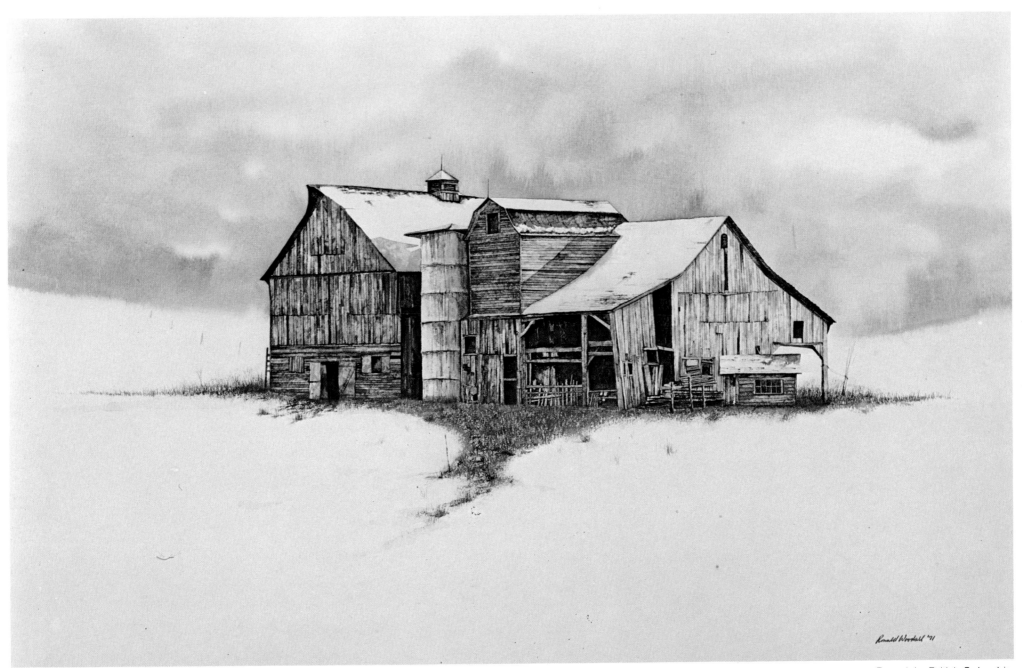

Rosedale, British Columbia

After the graduation dance for the Class of '75, some of the high school kids from Merritt drove up to Stump Lake, just north of Nicola, and burned down the old Planet Mine. It was all good fun, I suppose, but they destroyed one of the few remaining British Columbia mine structures that the highway traveler could see from the road.

It began operations in 1929 when, at one o'clock on March 15, the wife of president P. L. Bancroft christened the mill with a bottle of champagne. The flotation plant started up and the two hundred dignitaries who had come on the special train from Vancouver broke into a cheer. They had high hopes, expecting to take out a hundred million dollars in ore. It was called the Planet Mine when it opened. A year later, metal prices had dropped, and work stopped. In 1932, renamed the Nicola Mine, it started producing again until a flurry of panic stock selling, a directors' upheaval, and a Price-Waterhouse investigation left the property in heavy debt. For $115,000 and some shares, it became the Consolidated Nicola Goldfields, then the Stump Lake Metal Mine, and most recently, the Stump Mine. After $44,000 worth of fruitless testing in the summer of 1964, the Stump was abandoned forever.

The weathered mill which the motorist could spot from the highway on the far side of Stump Lake was the only visible element of the massive mining complex on Mineral Hill. There were twenty-two veins in all, including the five main shafts: Planet, Silver King, Enterprise, Tubal Cain and the giant Joshua. These were connected by a main crosscut which ran half a mile into the mountain.

About a month and a half before the Planet Mine was finally set afire, I returned for one last look. Here are my notes: "Now, a damp and clammy wind moans from the tunnel mouth, even on the warmest day. Foul water, tinted green by the copper, seeps between the twisted and scattered ore car tracks. The great mill is stripped and cavernous. Your footsteps echo and the birds protest your intrusion. The emptiness of the massive structure and the enormity of the bared concrete machinery seatings create a bizarre atmosphere. It is almost like seeing a section of one of the great pyramids under cover. In the mine office, the floor is littered with Consolidated Nicola Goldfields time sheets and day reports from the winter of 1939. I read one and learned that on February 18, J. Mayervich drilled and blasted 16 holes at Level Six.

The bunkhouses are garbage heaps of discarded work boots, corroded battery packs and old *Liberty* magazines, strewn around the oil barrel wood stoves. Stained, bright blue cardboard insulation hangs in shreds from the ceilings. There are enough names scratched into the walls to fill a phone book. Everything is smashed: doors ripped off hinges; window frames pried from the walls; toilets sledgehammered and the shower plumbing grotesquely twisted. In the mill, heavy machinery has somehow been toppled and the cast-iron footings bent. I will never be able to understand why vandals exert such Herculean efforts to destroy without gain.

Sitting up on the old water tower, contemplating the contrast between the battered gray remains of the big mine and the bright orange vinyl tents, the silver Winnebagos, and the powder blue water ski boats on the lake below, I wondered why this place appears more threadbare each time we return to it. Suddenly, the answer came to me. The campers down on Stump Lake are systematically disassembling the old Planet Mine to fuel their wiener roasts!"

Well, the students from Merritt found a quicker way. But kids will be kids.

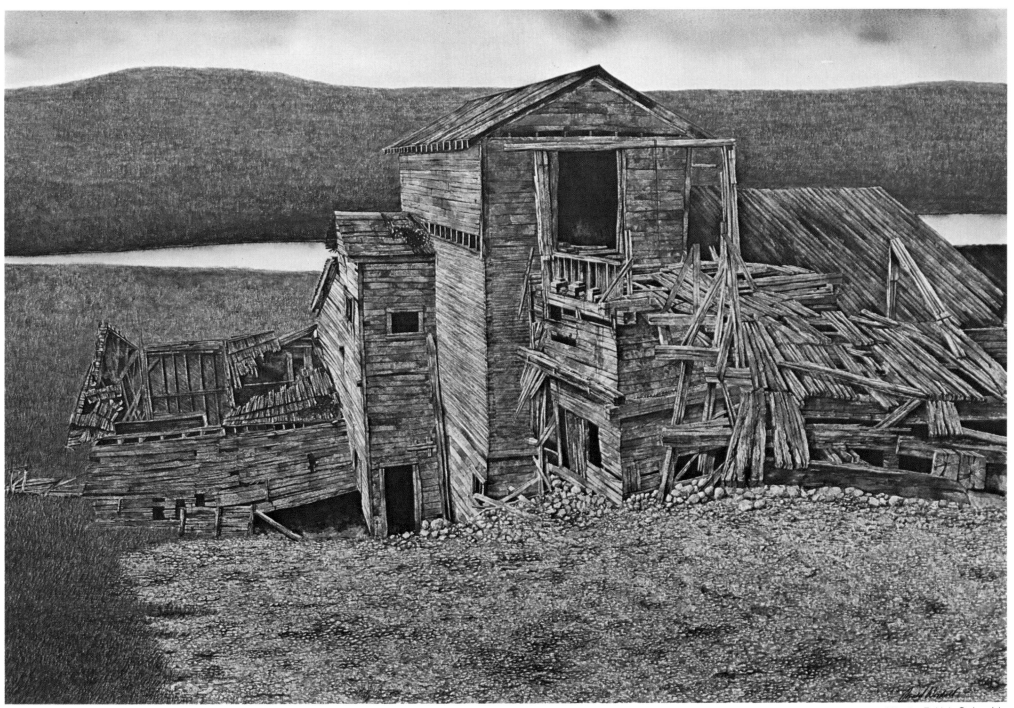

Nicola, British Columbia

Traveling at sixty-five or seventy miles an hour, you might not notice the grayed old farmhouse beside the Trans-Canada Highway at Irvine, Alberta, near the Saskatchewan border. (In fact, you might not notice Irvine.) But like all farmhouses, it has a history of sorts because someone built it and lived in it. Here is the simple story of a simple house beside the highway.

William Harris was a Welsh tin miner, and Hilda Toll a minister's outcast daughter who had married a pub-keeper. When Hilda was widowed, Harris convinced her to marry and emigrate to Canada. In 1882, they arrived in Griswold, Manitoba with Hilda's three children. Harris worked for the railway, and in 1886, they had a son of their own, Llewellyn. That same year, the Canadian Pacific Railway reached Irvine where a large depot was constructed to service the outlying areas. The RCMP had brought law and order to the district and had stopped the whiskey smuggling, the gunfighting and the Indian skirmishes. The American buffalo hunters had gone. Robert McCutcheon had slaughtered the last herd on Irvine Flats in 1882 and the Alberta buffalo had vanished. The area was safe for settlement. So in 1887, Harris moved to Irvine, seeking land and opportunity. He worked for the railway and by 1890, had built a tiny log cabin homestead just west of town. There, the two adults and four children weathered ten prairie winters.

The farmhouse in the painting was not built until 1900. Hilda and William were to live and farm there until their deaths in 1929 and 1931. Two sons went to work for the railway and one was killed in a locomotive accident in 1903. Llewellyn started a real estate business in Irvine. Hilda's daughter Elizabeth stayed home and cared for her parents. She eventually married her childhood sweetheart when she was seventy and he eighty.

By 1910, Irvine had grown to a population of 1,000 and had become a busy commercial center. Hilda Harris operated the post office in the railway section house. Immigrants were pouring in from eastern North America and central Europe. They stayed at the town hall until their rough sod, mud or log houses were built. Farm life was exhausting and harsh. The settlers withstood blizzards, dust storms, drought and disease. The grasslands were unfenced and the cattle ran free.

Llewellyn Harris died in the flu epidemic of 1918. Five children were left; Jim, the oldest, was six. His widow and children moved in with the grandparents. There was no place else to go. They bounced around, living for a while in town, and then sought work in Medicine Hat. They returned often to the farm during the Dirty Thirties to help with the Russian Thistle harvest. Because they could not afford shoes, their ankles bled at the end of a day's work. As the thirties progressed, things got worse. The winds blew off the topsoil and there was a drought. In 1934, Elizabeth Toll sold the house.

Jim Harris, now retired in Medicine Hat, recalls that grandfather William was a true character. They called him "Doublethumb Harris" because he had an extra thumb on each hand. For years, he used to run the mail into the barren Cypress Hills. Whatever the weather, there was a surefire way to guarantee delivery: simply have a fresh bottle of whiskey ready for each run, each way. The mail always got through.

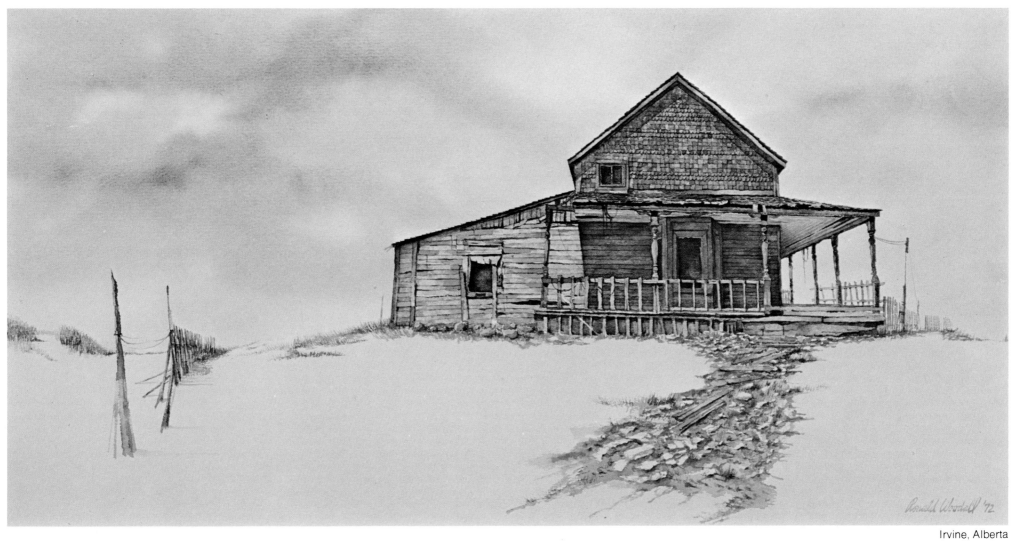

Irvine, Alberta

It was the summer of 1974 and we had been photographing mining towns in Utah and Colorado and were returning to Canada via Montana. As we approached the town of Norris, an image of its hotel, with its sign The Klondike, formed in my mind. I loved that building. Having painted it a few years earlier, I was eager to see it again and to get a little history from its owner. As we came over the rise at the south end of town, I remember the shock of what I saw. The entire top floor of the building was burned off. I felt like crying.

We went to see Albert Hokanson, the old prospector who had been living in the Klondike when we first found it. Now he had moved into an old, ugly mobile home parked beside the building. "That fire just broke my heart," Hokanson told me. The building burned on the night of June 6, 1972. He has no idea how it started. The upper floor had been a storehouse of valuable antiques and thousands of rare old books. Inside, everything was black. The stained wallpaper hung in shreds and the water-stained ceiling drooped precariously. The original saloon bar and the curved glass showcases were buried under a crust of soot and burned debris, as was the unusual square grand piano that had been imported from Switzerland at the height of the Montana gold rush.

As the date on the cornice used to proclaim, the Klondike was built in 1900 by a man named Carlson who ran a rootin'-tootin' saloon on the lower floor. There were gunfights on the street out front and the walls of the upstairs rooms were peppered with bullet holes. In the thirties, after the town had quieted down, the building served as Ira Young's general store and barber shop.

Albert Hokanson drove streetcars in Minneapolis, Minnesota until one day in 1928 he got bored and decided to try a little mining up around Butte. The market crash of 1929 closed the mine and sent him back to the streetcars. Fifteen years later, in 1944, the mining bug drew him back to Montana. He staked a claim in the hills near Norris and bought the Klondike to open a rock shop and antique store. In 1947, he shipped his last twenty tons of ore. Assaying at a mere $90 a ton, it was no longer worth the trouble. But the rock shop prospered. Hokanson seems to know a lot about minerals and he sells to collectors all over the world. Before the fire, his walls were covered with calling cards from almost everywhere.

The top floor of the Klondike was not the only thing that was missing. We noticed that Hokanson's little dog "Dawg" now had only three legs. "He took on a big dog. Got it chawed off. Got more guts than brains, that dog of mine." We asked if Dawg had much trouble getting around. Hokanson thought for a minute and said "Don't matter none. We ain't goin' nowheres."

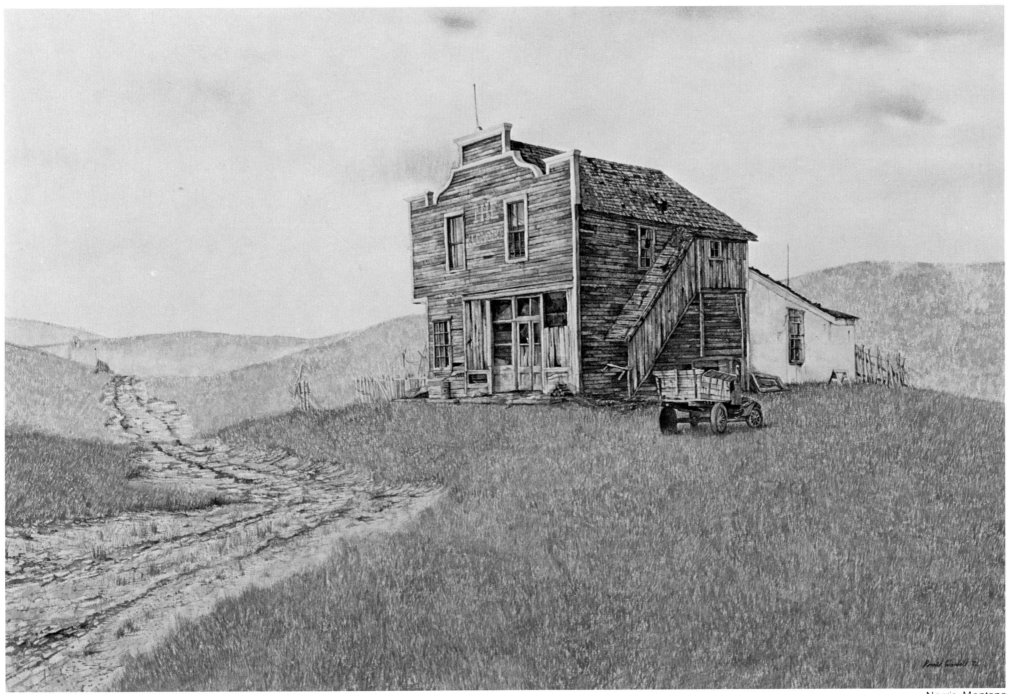

Norris, Montana

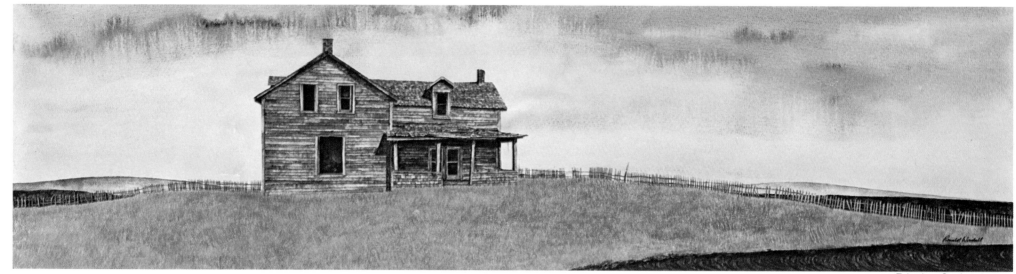

Edgeley, Saskatchewan

Here are two lonely farmhouses, favorites of mine that I have painted a number of times. In arranging the paintings for this book, I combined the two because they were both long, horizontal paintings which I thought might go well together. At one point, when planning the page, I laid them one above the other and was struck by their similarity. Although these two farmhouses are 700 miles apart, to the casual observer they might seem almost identical, but on closer observation you will see that they are quite different.

The house in the above painting is one I spotted just south of Saskatchewan Highway 10 across from the town of Edgeley which is about midway between Fort Qu'Appelle and Regina. I particularly remember blazing a trail through windshield-high wheat in my rush to get to the building. Afterward, I felt terrible about the wake my tires had cut through the bright golden field and vowed never to do that again. The house was vacant but still had enough furniture to be livable. Most likely, it is one of those thousands of prairie

farmhouses that serve as harvest season homes for the "suitcase farmers" who commute to their fields from Regina and Saskatoon and Prince Albert.

The farmhouse at right is near Rock Creek, British Columbia, a tiny Kettle Valley community that enjoyed a short but hectic gold rush in 1860. The house was built in 1913 by a couple of partnering farmers named Harry Brown and Sherwin Warnock. It was abandoned sometime during World War II and has never been used since. This farm has a number of other superb outbuildings, including a rambling log stable with a huge "Jesus Loves U" painted on the face. The sign is a favorite subject for photographers traveling Highway 3. About a hundred yards behind the house, the flat bench of pasture drops sharply to the creek below. The highway makes a wide sweep around the farm and then begins a series of switchbacks into the valley. Several times during the descent, the house comes into view and, in its isolated cliff top setting, it is spectacular.

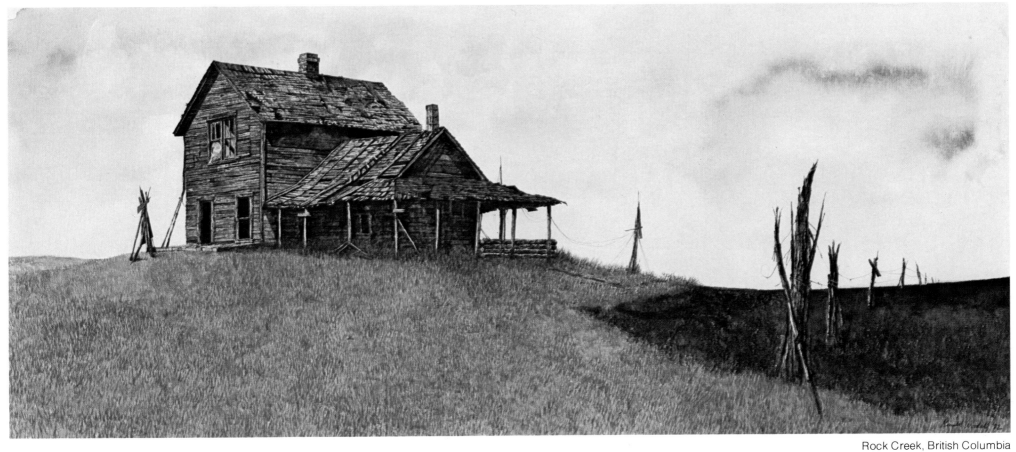

Rock Creek, British Columbia

When I painted the threshing floor of this barn on the old Cariboo wagon road about thirty-seven miles short of Barkerville, I had no idea what a famous barn it was.

The building dates back to the 1860s and is the haybarn at Cottonwood House, the only gold rush roadhouse to have been preserved by the province. In the last few years, the buildings at Cottonwood have been completely restored as a twenty-one acre provincial historic park. They are fenced and groomed and guarded and quite different from the first time I saw them. The plaque out front reads: "For half a century, the Boyd family operated this haven for man and beast. Here, weary travellers found lodging, food and drink. Here, fresh horses were hitched to stage coaches and miners bought supplies. This historic road house, built in 1864, stood as an oasis of civilization on the frontier of a rich new land."

By 1866, the Cariboo Road was through and Cottonwood was a very busy hostelry and general store. It was also a popular saloon and gambling parlor, according to some of the entries in John Boyd's original account books. At the store, goldseekers could buy tools, grub, work clothes and medicine. Horses and mules were fed and cared for at the stables and a man's grain could be stored in the barn's bin. Cottonwood was a toll station, too, and a regular stop on the Barnard Express stage route.

The buildings at Cottonwood are, in my view, the best survivors of the Cariboo gold rush and because of the Barkerville fire of 1868, just about the oldest.

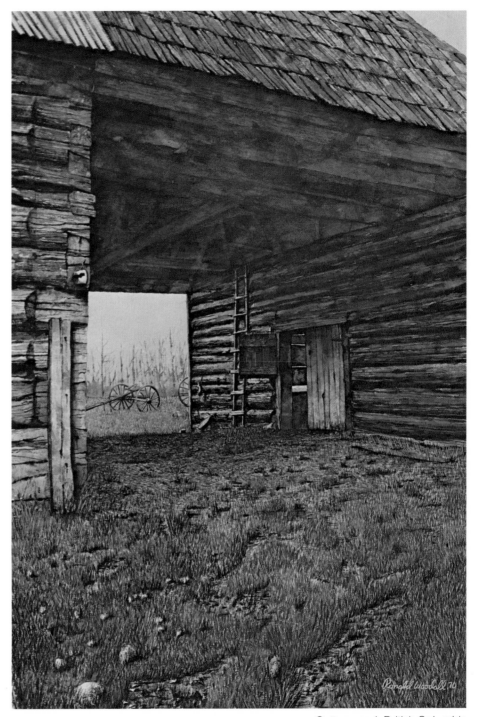

Cottonwood, British Columbia

One day in 1970, I made a mistake that I will not make again. Just north of Lillooet, British Columbia, on the Fraser River, I saw an abandoned but intact native village with an old mission church. Because it was across the river and doubling back would have meant a thirty-mile detour, I decided to catch it on my next trip. A month later, a grass fire burned the buildings to the ground.

With this bitter lesson learned, I returned to the area intent on collecting all the mission church buildings near Lillooet. A remarkable number exist in the area. This is the one I like best. It is on the old Cayoosh land, down the little road that runs the four miles from Lillooet to Seton Lake. The bell is gone, the stovepipe chimney is gone, and during the last decade, the altar and pews have disappeared. It is difficult to pinpoint when the building was last used, but it was probably for the funeral of an Indian boy who drowned in the Seton power canal in 1965. Father D. D. MacDonald OMI, the mission priest, held the service. The church was furnished at that time, but this seems to have been the start of its deterioration.

Dating pioneer Indian buildings is an imprecise and frustrating pastime. The most I can ever learn is that "It's pretty old!" Indians are wise people and seldom waste energy running around seeking trivial information like construction dates. So I checked with "Ma" Murray, Lillooet's famous and outspoken newspaper publisher. To my surprise, she dated construction around 1865, just after the Royal Engineers had completed the Douglas Trail. While very old for British Columbia, this date seems possible. In the late 1850s, with the California gold rush over, attention turned to the Cariboo. A route northward was needed. A road through the Fraser Canyon seemed, at the time, too difficult to build, so Governor James Douglas ordered a road to be built to follow the trail cut by a Hudson's Bay Company guide, Alexander Anderson, in 1846. The work was begun in 1858 and completed four years later, the labor being supplied by 500 miners who were anxious to get to the Cariboo. Douglas hired them to build their own road to the gold creeks, aided by the Royal Engineers. The Douglas Trail ran 112 miles including fifty-four miles of steamer travel on three lakes. Between Anderson and Seton Lakes, freight was portaged over a mule-powered train on wooded tracks. This was British Columbia's first railroad.

The little church in the painting stands beside the original road. It was probably built by miners, who often helped with the financing and heavy construction, leaving the natives and priests to complete the finishing touches. Anyhow, as the old man said, "It's pretty old."

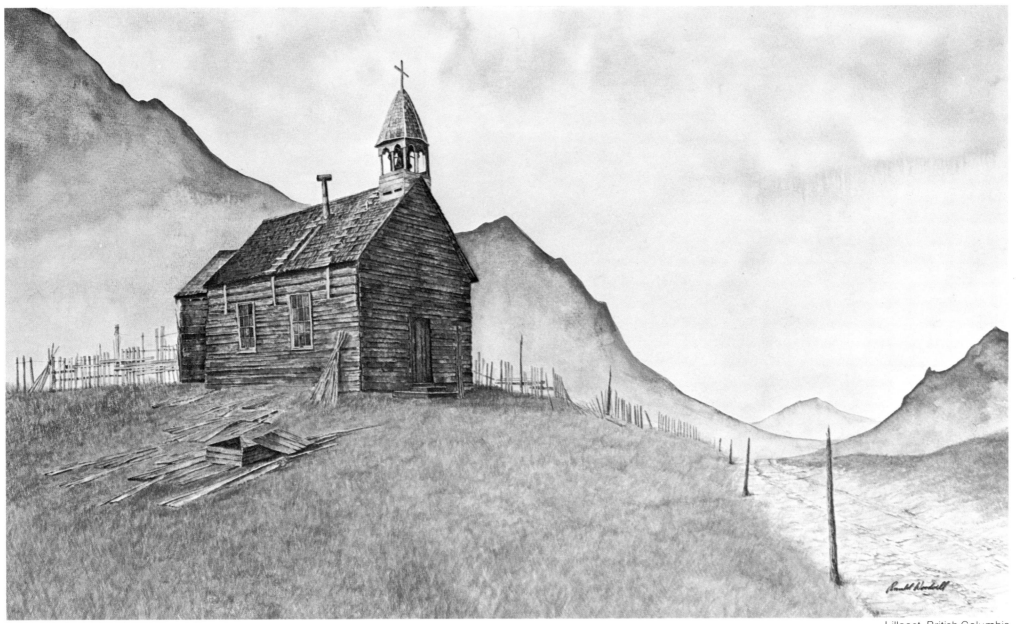

Lillooet, British Columbia

Hunting for old buildings has all the hit-and-miss excitement of prospecting, so it is fitting that old worked-out mining areas usually offer a new bonanza for architectural prospectors. Mining towns grow quickly and die quickly, and so remain curiously frozen reflections of an era.

There is an area in Okanogan County, Washington, just south of the British Columbia border, that is incredibly rich in vintage abandoned buildings. It is one of those remote places that few people have much reason to visit, and consequently it has been left miraculously intact.

In 1859, some prospectors heading for the Fraser River gold rush struck pay dirt on the Similkameen River before they reached the border. Shortly afterward, the entire mineral belt was proclaimed Indian land by executive order and all whites were obliged to leave the area. Thirteen years later, the local Indian chief moved his people to the Colville area and the mineral belt reverted to public domain. Miners poured in and dozens of colorful communities sprang up, with intriguing names like Ruby, Havillah, Concully, Loop Loop, Nighthawk, Weheville, Oroville, Bolster, Wauconda, Chesaw and Old Torado. Most of them are still there, frozen in the 1900s. If you like old buildings, a tour of Okanogan County is ecstasy.

While I have photographed hundreds of structures in the area, this old farmhouse just south of Chesaw is one of the few I have painted. At one time, it had a great double balcony across the front and must have been a handsome homestead. Now, it is filled with winter feed.

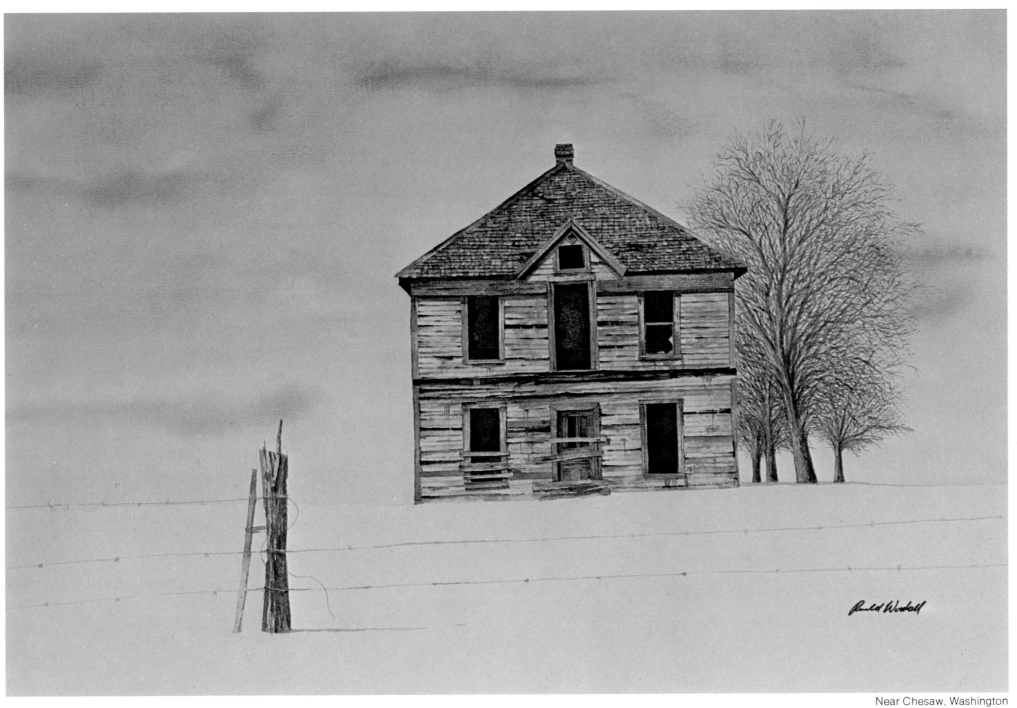

Near Chesaw, Washington

On the Gulf Islands off the coast of British Columbia, only a few pioneer farms have survived the orgy of recreational land development.

There is nothing special about farms and barns on islands. They are certainly no different architecturally from the barns you find on the mainland. But they somehow *seem* different. This feeling is a subtle one that probably stems from the knowledge that you are surrounded by water. The din of highway noise that is usually present even in the most rural of mainland areas is replaced by the lapping of waves and the dull throb of diesel-powered gillnetters somewhere at sea. The usual barnyard smells are combined with salty, fishy sea breezes. Cattle wander freely down traffic-free dirt lanes and are slow to move for the occasional vehicle. Sheep nibble on beach vegetation and seaweed. Look in one direction and you see a pastoral farm scene; turn around and you are looking at a sea-scape. It is quite strange. But then, islanders would surely feel the same disorientation on the prairies or in the Rocky Mountains.

What drew me to this barn on Saltspring Island, near Victoria, were the four panels of blackness exposed when someone stole the lumber from the end walls of the cattle stalls and the hay mow. This deed transformed a rather dull building into an irresistible painting subject.

The barn is on Long Harbour Road which leads to the embarkation point for ferries connecting with the smaller islands. It was built in 1900 by Geofrey Scott for the Scott Brothers Farm. A 187-acre dairy spread, it has not been used since the end of World War II. The area is filling up with small summer homes and the farm appears to have been broken up. Like so much of the Canadian Gulf Islands, the property is now American owned.

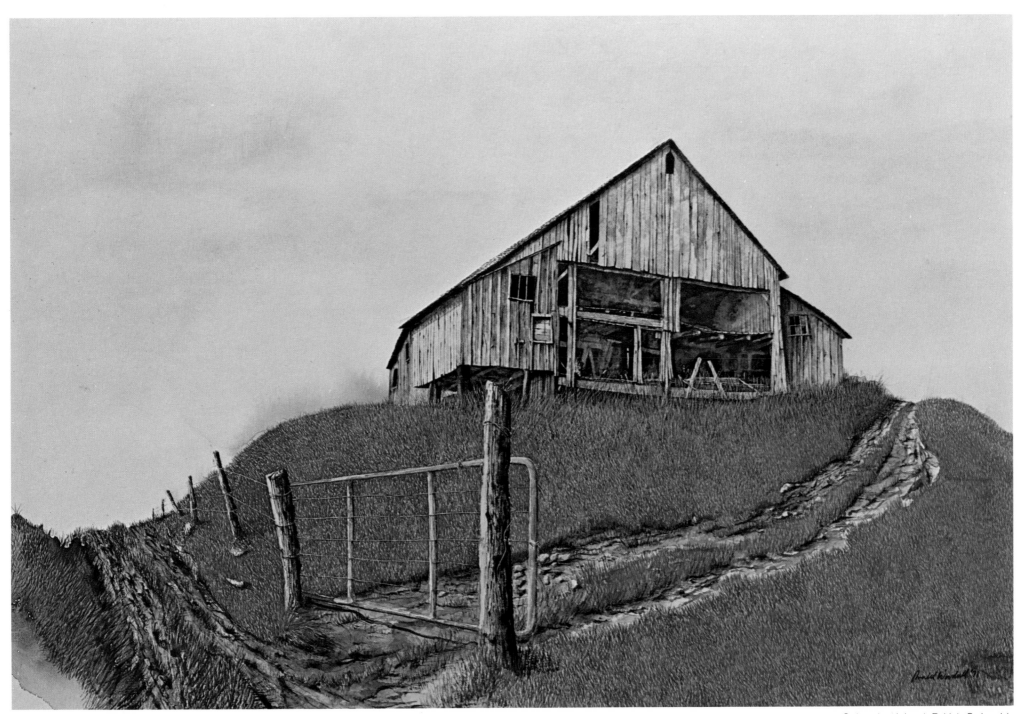

Saltspring Island, British Columbia

An old fisherman I met on the government wharf at Sooke Harbour told me that the little shacks I had painted were originally housing for the Indians who came to work the fish traps during the salmon run. There used to be a string of shacks running along the water's edge, and these are the only ones left.

Sooke is a small community twenty-six miles west of Victoria, British Columbia, on the southwest shore of Vancouver Island just below the forty-ninth parallel. It has a calm and protected harbor tucked snugly behind a natural breakwater called Whiffen Spit. The British found the place in 1842 and soon after, Captain Walter Colquhoun Grant had settled a hundred acres of waterfront. Many more settlers followed. The warm climate sustained fruit orchards, and the thick forest provided richly for logging and lumbermill operations. The Strait of Juan de Fuca was alive with salmon, cod and herring, and the beach beds of the harbor were thick with clams, oysters and shrimp. There was no road through from Victoria, but it was a good place to homestead.

Oddly enough, it took a gold rush to put this fishing port on the map. In 1864, a discovery was made a few miles up the Leech River, which empties into Sooke Harbour. Leechtown materialized overnight, and the only way to the Leechtown goldfield was through Sooke. It was a modest strike and nobody got rich, but gold fever was in the air and steamers began arriving daily from Victoria. Leechtown died quickly, but Sooke Harbour was to see better days.

In 1904, J. H. Todd built a fish trap at the mouth of Sooke Inlet and another off Otter Point. Soon, there were fish traps all along the southwest coast for twenty miles on each side of Sooke. A complex of wharves and fishery buildings grew in the harbor and a great many area residents depended on the traps for a livelihood. The traps siphoned off less than three per cent of the huge salmon runs around the end of the island to the Fraser River but, from the beginning, were resented by fishboat operators who tended to exaggerate their effectiveness. By 1935, when Washington State abolished its traps, opposition to the Sooke operation grew so strong that representation was made to Ottawa and the matter was referred to a Royal Commission. The resulting Sloan Report of 1940 allowed Sooke to have the only legal fishtraps on the West Coast: the commission found that trapping was the only commercially feasible fishing method for the area and that indeed, only a fringe of the Fraser River run was caught. But what probably influenced the decision to make an exception was the fact that the Sooke traps provided Canadian fishermen a chance to get some of the Fraser River run — considered by them a Canadian run — before it entered the American waters of the San Juan Islands and the waiting American fishing nets. During World War II, an attempt was made to increase the number of traps at Sooke, but the request was denied and by 1950, the traps were gone.

Today, Sooke retains little of its fishing village atmosphere. The town clusters around a small shopping center and several commercial buildings strung along the highway. The modern government wharf has a few net sheds and a fishing gear store. A hundred feet behind the rotting shacks on the beach, a small cairn marks the site of Captain Grant's sawmill, noting that he returned to England only three years after settling at Sooke.

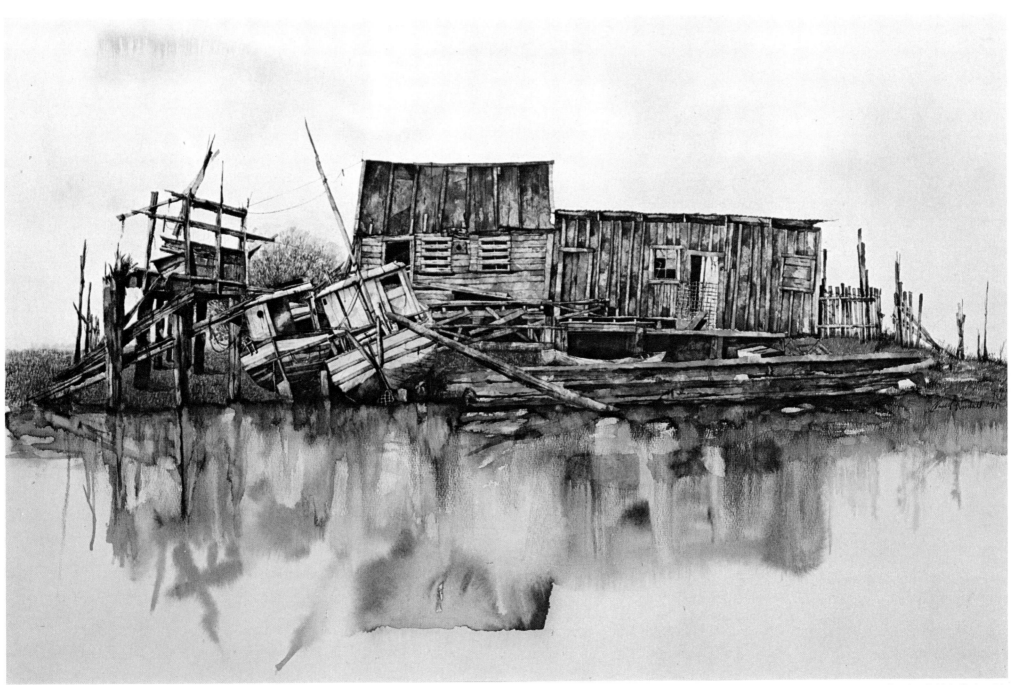

Sooke, British Columbia

In the year 1867, two weeks and a day before the Fathers of Confederation sat down in Charlottetown to pull the Canadas into a single nation, Cornelius O'Keefe and Thomas Greenhow of Oregon were driving 180 head of cattle up the Okanagan Valley with the intention of selling expensive steaks to some rich and hungry Cariboo gold miners. They stopped for a while to fatten their herd in the lush meadowlands north of Okanagan Lake and realized that acreage rather than gold was the real fortune to be found in the West. So O'Keefe began to amass what would be a 15,000-acre ranch and became the first real cattle baron of the interior.

The O.K. spread was big enough to be its own parish and it was not long before good Irish Catholic Cornelius O'Keefe was heading a list of donors for a church building fund. He put himself down for $150. The Greenhow Ranch pledged $100 and by 1886, donations were coming in from both Catholics and Protestants, all up and down the valley. It took $600 to build the little church and they called it St. Ann's. Today, it is the oldest Roman Catholic church in the British Columbia interior.

The ranch is now owned by Tierney O'Keefe, the youngest of fourteen children, born when Cornelius was seventy-four. Tierney is a lean and leathery man who looks every bit the rightful heir to the O.K. empire. But the O.K. is smaller now. It has been sold off in bits and chunks, and one corner has even become a golf course. In 1965, the ranch was opened to the public and that year, the O'Keefes gave us a pleasant, private tour through the elegant Victorian interior of the enormous seventeen-room mansion that Cornelius built between 1880 and 1900. When we first saw them, the ranch buildings were in their original weathered condition and St. Ann's stood alone in the long grass. But during the next two years, the

O'Keefes completed an ambitious restoration and on June 15, 1967, a century to the day from Cornelius' arrival, they opened their historical exhibit. The homestead and old ranch buildings are grouped together with wooden sidewalks and gas lamps added to form a sort of "Main Street." You can wander around the 1872 general store and post office, where Cornelius was the district postmaster from 1872 to 1884, the original 1868 ranch house which later became the bunkhouse for the hands, the original blacksmith shop, the Chinese cook's cabin, the wagon shed, and St. Ann's.

Something about St. Ann's makes it stand apart from the restoration, perhaps because it never had any fresh cow-town signs painted on it, and was left alone. The little sign inside says it all: "Everything is original except the flowers on the altar." The interior is simple and dignified. The pews are undecorated but well built. There is a little fretwork filigree cut into the communion rail. The original vestments, candlesticks, missal and organ all remain. The very worn original carpet down the center aisle leads to the gilded altar which stands tall and hard white against the oft-varnished vertical tongue-and-groove wall. Atop the altar, there is a striking Sacred Heart figure and nearby, a small statue of St. Anthony. A stovepipe runs the full length of the nave and disappears into the end wall, bringing everything into perspective. St. Ann's has no bell. It never had a bell. Nobody seems to know why.

The summer of 1975 brought some bad news; the O'Keefes announced that they had grown too old to run the operation and could get no help from the provincial or federal governments. At the close of the season, they plan to lock up the buildings and sell off the contents. A sad ending.

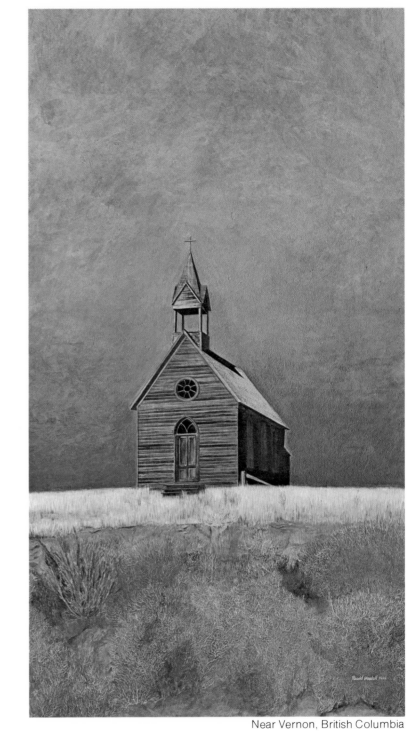

Near Vernon, British Columbia

The trouble with barns is that they are the best buildings to paint and absolutely the worst to write about. Not much happens in a barn. For a farmer, it's a place to milk cattle and store hay. For me, it is a beautiful object to be seen and admired. It is the building which is allowed to age most gracefully and blend most naturally into its environment. It is the purest and simplest of folk architecture. Beyond that, there is little to say about most barns.

What is worse than the barn with no story is the barn that I cannot find again. Often, when a barn is not on a mapped road, I lose it forever. My notes always place it in a region, but pinpointing it again is a frustrating matter, particularly if I am seeking information by mail. This barn is an example of the problem. I remember that we came upon it in an autumn sunset and that the bright green hill was unnaturally intense against the dark sky. In the small watering pond below, a freshly painted yellow punt glowed as though it was its own light source. The barn, partly collapsed, seemed to me a classic example of a ruin as sculpture. I remember walking a wide circle around the building and noting that it was aesthetically pleasing from every direction. That, they will tell you in art school, is the true test of a successful piece of sculpture, and in this building, there were a dozen paintings from a dozen angles.

But the barn is a lost building which I will never likely find again. I know only that it is somewhere in the rolling foothill grasslands of southwestern Alberta, near a place called Immigrant Gap on the Montana border. Or, by now, it may be lining the walls of a Calgary restaurant. I'll never know.

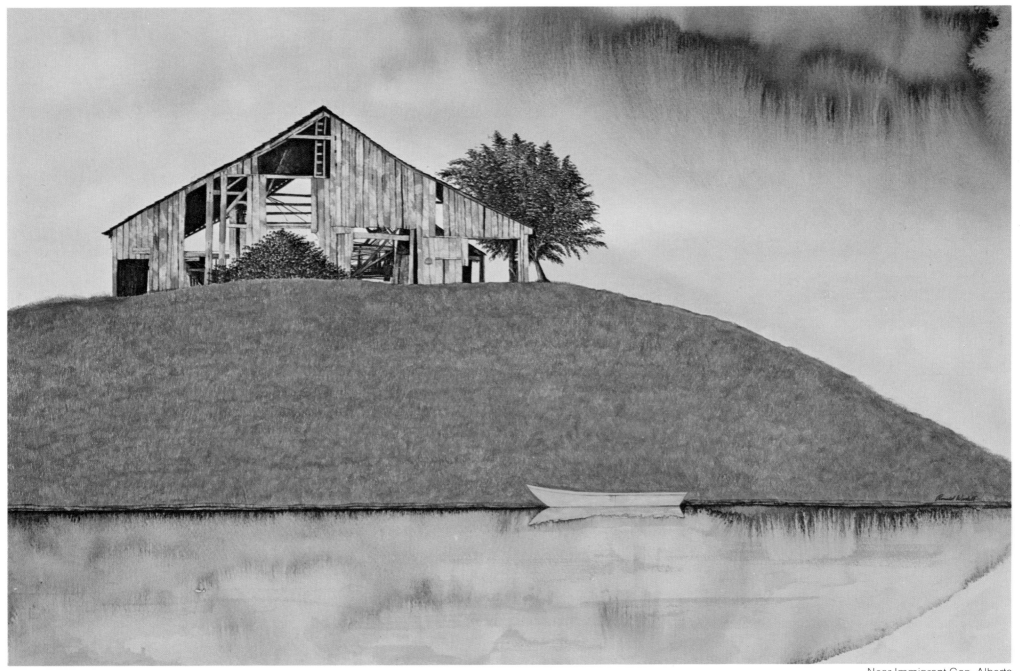

Near Immigrant Gap, Alberta

At Chilliwack, British Columbia, the Nicomen Slough splits the Fraser River for a distance, and forms a seven and a half mile long flat silt bar called Nicomen Island. The island is perfectly suited to dairy farming and is heavily populated with Holsteins. Consequently, it has a fine selection of rambling dairy barns.

The old barn in the painting was built in 1915 by an island pioneer named Thompson. It still stands at the corner of the Nicomen Island Trunk Road and the Lougheed Highway, about a mile and a half east of Dewdney. It is now owned by the Dell'Oca family, farmers of Italian descent who moved to the area from California.

Nicomen Island has been the victim of many floods and has often been completely submerged under the waters of the Fraser during spring runoff. These days, the island is completely ringed with a high flood dike. As can be seen in the painting, this barn is built against the dike. More accurately, the dike has been built around the barn, taking a slight jog at one corner of the building.

Down in the thickly whitewashed byre that forms part of the structure, there are stalls and feeders for about seventy cattle. The hewn square beams are set on huge untrimmed posts, still bearing the irregular shapes of the original tree trunks. The exterior planking is heavy with a mossy deposit of age. An old blue Ford tractor sits by the machinery shed.

For the longest time, despite living in British Columbia, I refused to put mountains into my paintings. Perhaps I had seen too many craggy purple peaks reproduced on card table tops. But one day, I saw an exhibition by an Oriental watercolorist and learned that paintings of mountains could be light and misty and pleasing. A few days later, beginning this painting, I realized that, as with many of British Columbia's buildings, it was the structure's relationship to the backdrop of the Coast Range which made it striking. So, with trembling hand, I put in a mountain! It looked all right. Maybe sunsets are next.

An interesting aspect to this barn is that a few boards are missing from the west wall so that when you stand in a certain spot, the opening frames a giant monastery, the Westminster Abbey, high in the hills above the city of Mission. In autumn, the sun sets directly behind the bell tower of the Abbey and the effect is magical.

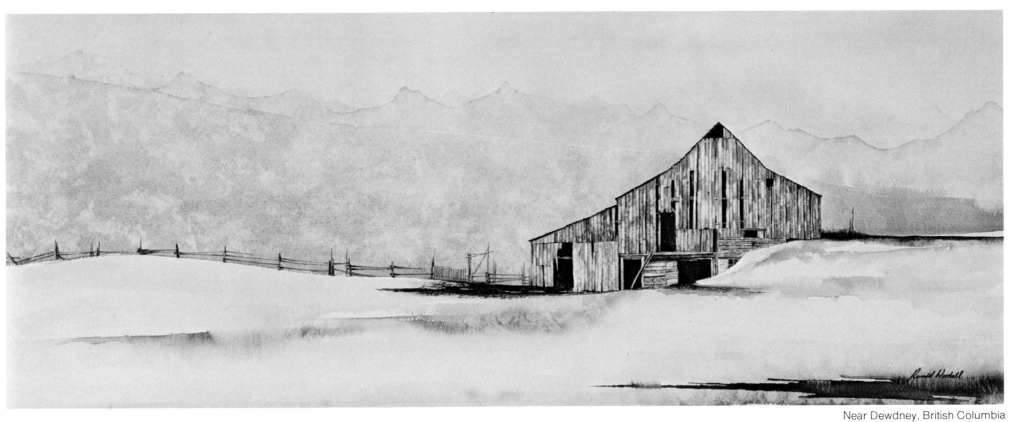

Near Dewdney, British Columbia

This is really a painting of silos. Up at the head of British Columbia's Fraser Valley, many of the barns have their silos capped with these enclosed sheds, necessitating the complex exterior bracing. From a painter's point of view, this bracing is delightful as it casts an intriguing pattern of curved shadows on the walls of the silo. An old farmer explained to me that because the area is so damp and rainy, the protective sheds were developed to allow the silo to be left open on top for added ventilation. In addition, the structure is big enough for a man to walk around inside, and permits feed to be piled three feet higher than the silo top.

While on Nicomen Island a short time ago, gathering information about the building on the preceding page, I stopped at a farmhouse, seeking a little historical data. Jack Brock and his family were having a big Sunday get-together but graciously spared an hour to talk about the area. In the course of our conversation, I produced a photograph of this painting and asked if they could lead me to the barn. "That's our barn!" they cried in unison. "At least, it *was* our barn." They then showed me the bare patch of pasture where the big building had stood. The four buildings in front, the pump house, the granary, the machinery shed and the dairy were still there, but the magnificent barn with its monumental silos was gone.

At the end of July 1970, some children were playing in the hayloft. They had a strip of cap gun charges and were exploding them with a hammer. The strip caught fire and was dropped down between the stacked bales of hay. Before the bales could be removed to get at the flames, the fire was out of control and the barn burned to the ground. The painting is dated 1971 and was done from photographic reference, and the Brocks' story explains why I could never locate the barn again. So many of my subjects disappear that I sometimes wonder if I might be a jinx.

The barn was built in 1929 by Walter Brock, where Rowan Road meets the Lougheed Highway, about a quarter of a mile west of the Dell'Oca barn. The Brock family ran about fifty head of Holstein dairy cattle. By 1950, Walter's son Jack, fearing more flooding and seepage, decided to build an extra silo so that he would not run short of feed. Jack's father had centered the first silo under the gable of the end wall and extended the ridgepole so that the capping shed was an integral part of the building. When Jack added the second silo, he simply built a matching gable. The resulting asymmetry is a good example of the accidental and evolutionary nature of country folk architecture, and illustrates why when we lose such a building, we probably lose the last of its kind.

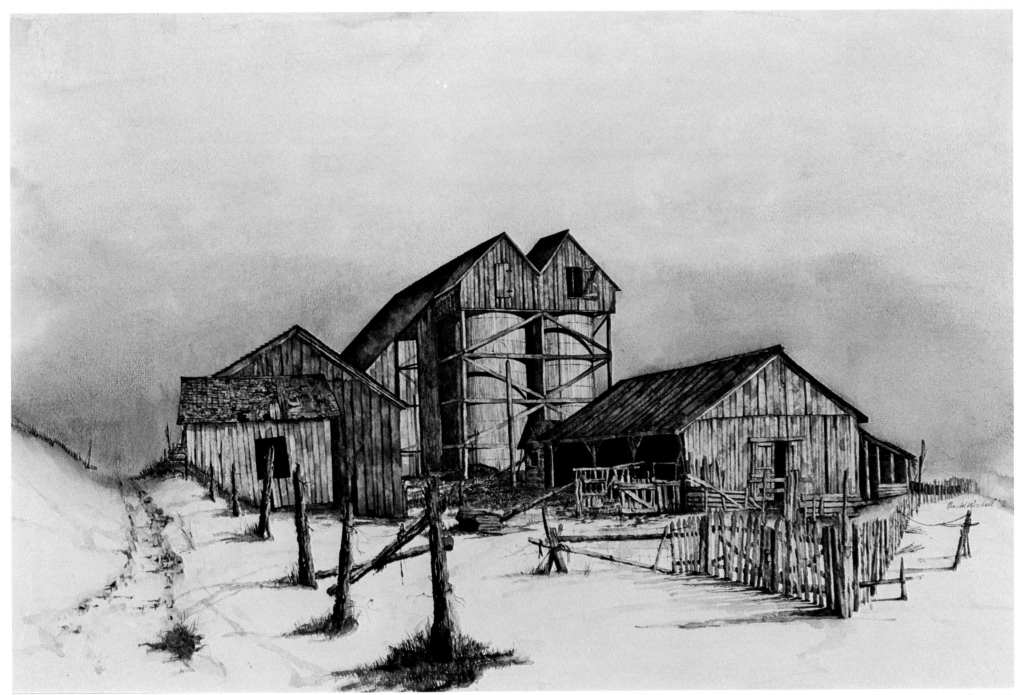

Nicomen Island, British Columbia

Here is yet another lost barn. I know where it is, but cannot find it! In the shadow of Mount Baker, there is a vast expanse of Fraser Valley farmland known as Sumas Prairie. The mountains rise steeply, almost vertically from Sumas Prairie, which is perfectly flat, rather like the bottom of a cooking pot. When you face due west, the feeling is more of central Saskatchewan than southern British Columbia. The barn is somewhere on that flatland.

It caught my attention one day because, as a watcher of barns, I found the geometry to be quite unusual. The break in the roof gable on both sides is unlike any classic barn configuration and, I have read, a purely western feature. This barn has a tall central hay mow and twin side sheds, one with a wide door for machinery and the other for livestock. Also, the fact that one side shed had a slightly higher roof than the other gave the building a peculiar asymmetry. From a painter's standpoint, I was particularly drawn to the raw wound of unbleached wood exposed by the recently removed siding and the tall vertical rectangle of hay and blackness, like a flag banner hanging on the gray wall. But it was, after all, just another of those unremarkable, anonymous derelicts I love to paint.

A few weeks ago, on Father's Day to be precise, I returned to Sumas Prairie with my young son Adam in a last-ditch effort to gain some information on the building before we went to press. We systematically drove every mile of the long straight rural roads that grid the prairie. Though we never did find the building, the trip was not in vain because I photographed every other barn in Sumas and got to answer several hundred pressing questions about cows.

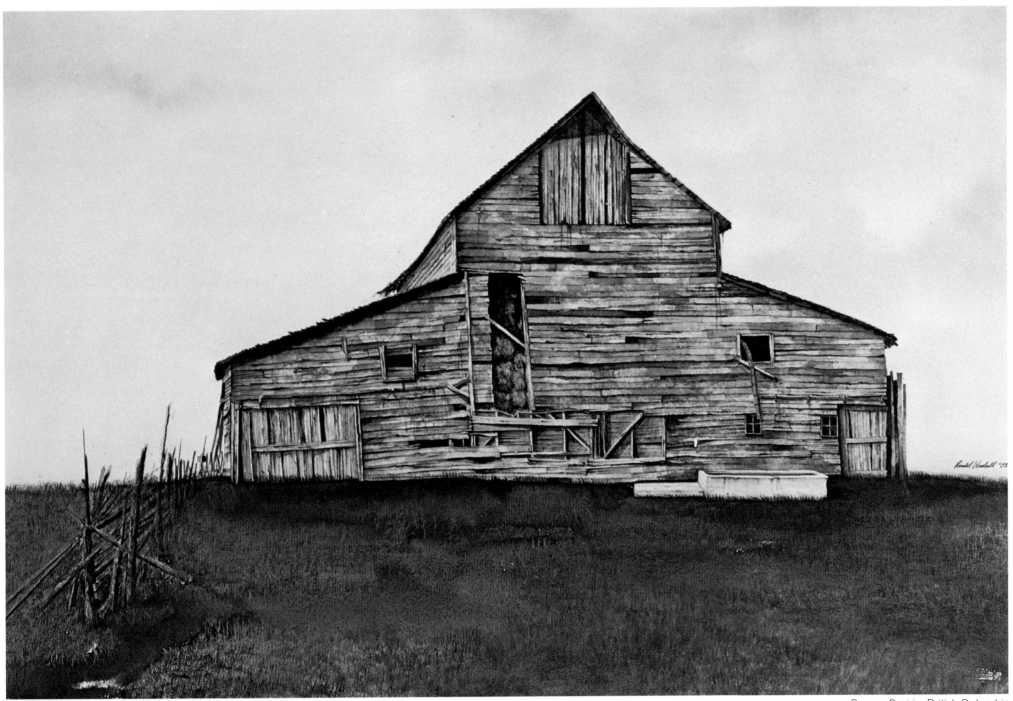

Sumas Prairie, British Columbia

Most buildings, it seems to me, look their finest in winter. Winter cleanses the world. It hides the garbage and the ugliness, and glazes the land in white. It creates a visual fantasy. It simplifies, even reduces, the landscape and transforms it into a lyrical monochrome. Confronted with this motionless and silent land, somehow the senses sharpen. Winter is the painter's season. As a painter of rural scenes, it is strange that I do very few winter ones. Probably, this is because so much of our collecting and traveling is done in the comfort of summer, and the buildings are painted the way I remember them. I must resolve to spend a January in Saskatchewan.

Log barns are particularly striking after a fresh snowfall. The old timbers become almost black by contrast. This grouping is an example. These buildings are just west of Salmon Arm, British Columbia, at the southernmost corner of Shuswap Lake, a dairy cattle area. As you pass them on the Trans-Canada Highway, you are exactly halfway between Calgary and Vancouver. We saw them on a morning after an all-night blizzard. Their scraggly, rough-hewn textures contrasted sharply against the fresh snowfall, and I remember thinking that these buildings seemed to huddle in the glaring whiteness like a family of great hibernating bears.

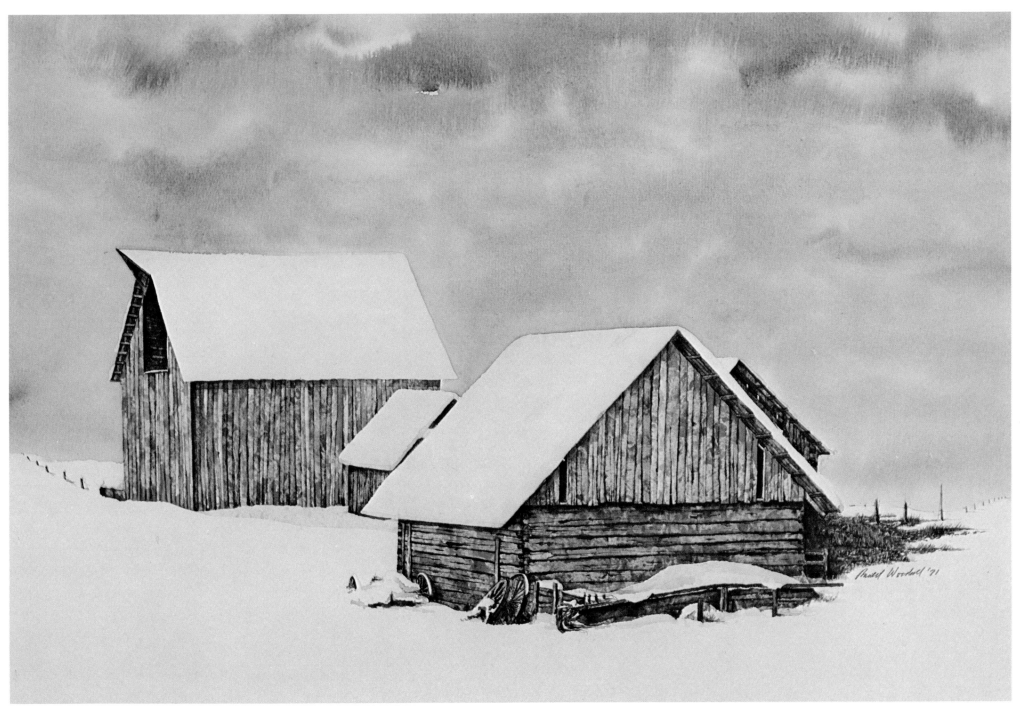

Salmon Arm, British Columbia

The southeastern corner of Wasco County is not exactly what comes to mind when you think of Oregon. The hills are barren and rolling and windy. The town of Antelope comes into view about halfway down a drop into the Antelope River Valley. It is an empty, scattered town with plenty of history. In the 1880s, it had its share of brawling and murders. In 1898, it had its inevitable fire which left only a few of the original buildings standing. One of these, just to the east of town, is a little jewel named the Antelope Methodist-Episcopalian Church. It was built in 1896 and dedicated in 1897. The lumber was donated by the Durham Mill and the labor by the faithful. That's how churches got built in 1896.

What struck me most was that the Antelope church had so much charm for a building in so stark a setting. It had an elegant steeple with a flared shake cap and delicate spoolwork around the belfry. The cross was gone, but the steeple felt right, even without it. Inside, the furnishings were sturdy and original with unusual V-shaped pews, hand built by James Hamilton, the carpenter who supervised construction. The original altar, which had been shipped from the east as a gift from the Episcopalian Archbishop, was still there. The little filigreed pump organ, purchased from McBeth's Occidental Hotel in 1897, was still there, as were the two ornate and still functioning cast-iron wood stoves. And finally, above the altar was a magnificent round window with slender crossed oval mullions.

When I first saw this church, I remember thinking that it would not likely survive. The woodpeckers had opened nesting holes in the walls. It had that tired slouch of a building with a rotted foundation. And sleepy, boarded-up Antelope just did not look like the kind of town that was about to save an old church.

I was wrong. Out of curiosity, I wrote to Antelope and received a reply from Kathryn McGreer, a pioneer Anteloper (Antelopian?) and church historian. Backed by newspaper clippings from the Portland *Oregonian* and the Dalles *Chronicle*, she told me in great detail how, over a four-year period, the restoration of the church had captured the enthusiasm and imagination of the fifty-one folks left in Antelope and how they begged and borrowed the materials, provided the elbow grease, and found the $8,700 to roof, paint, plaster, wire, light and revive the building. It has been renamed the Antelope Community Church, and non-denominational services are held at 6:30 on Sunday evening if there is a preacher available. Usually, the Reverend William Mai drives the forty-seven miles from the metropolis of Kinzua.

Mrs. McGreer tells a story about the original Sunday School teacher, Mrs. Lilly Dam, who was "as straight laced as her corset." She could never bring herself to call her husband, the church superintendent, by his real name. She called him "Brother Darn."

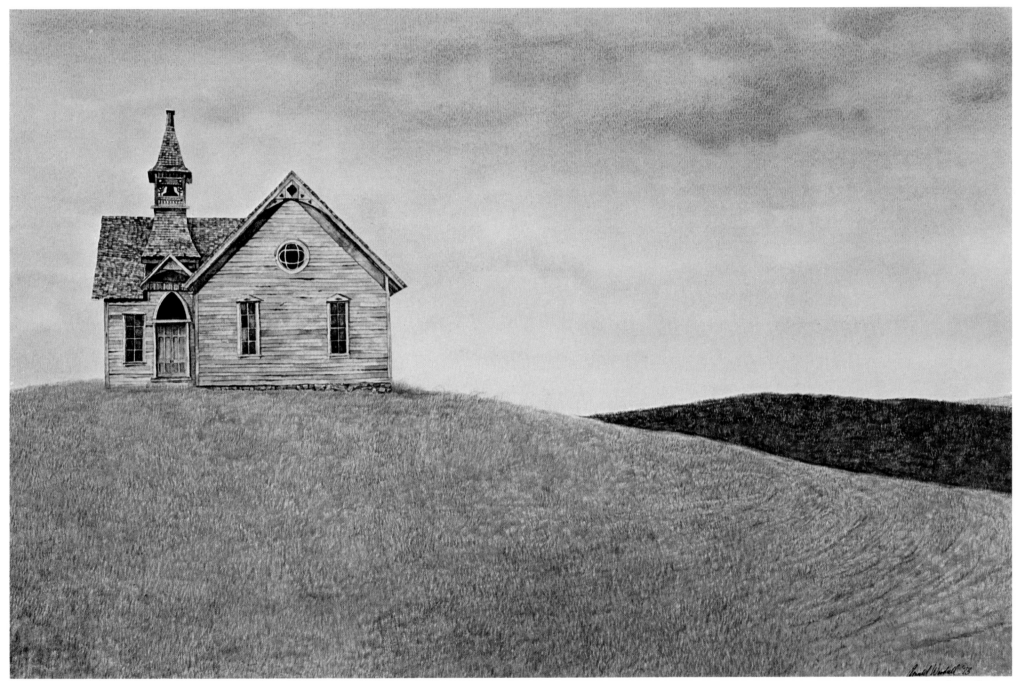

Antelope, Oregon

These are the wharf buildings at Winter Harbour, the last little outpost in the northernmost inlet on the west coast of Vancouver Island. I went there in a seaplane which followed a logging road through a narrow valley. We seemed to be three feet above the tree-tops and three feet below the clouds. It was like driving in a very fast, very *tall* truck.

While there, I met a remarkable man named Bill Moore who runs a logging operation which is one of the rare holdouts of private enterprise among the forestry giants. The Moore family has been logging there for over forty years. Bill, a rugged guy who might remind you of Anthony Quinn, knows his business thoroughly and is considered an authority on safety. But Bill also writes poems and stories and books about life at Winter Harbour. He was working on a musical comedy about logging. And why not? Every few years, Bill holds a jazz festival at which as many as 2,000 musicians and buffs attend, cramming this community of sixty-five. Some of Dave Brubeck's sidemen made it in 1967. In 1971, Bill built a Centennial park. In 1965, he hosted General Rockingham and the Canadian Army for a bout of war games. Every Christmas Eve, Bill and his friends board his meticulously refurbished tugboat and sail from Downtown Winter Harbour, which he calls the camp, to Uptown Winter Harbour, the settlement proper, a mile seaward. With bells tinkling and lights twinkling, they moor in the mist offshore and sing Christmas carols to the tiny community. This man who paints his trucks and bulldozers a shocking hue he calls "Bikini Coral" has found innovative ways to make this fog-shrouded outpost a joyful

place. With three sons, the Moore dynasty in the inlet may go on, but if eldest son Patrick is any indication of tomorrow's logger, the style could change. He has a Ph.D. in Ecology.

The inlet was first settled in the 1880s by the Ben Leeson family. He was a Hudson's Bay factor and is buried on Moore land. The large Indian population was virtually wiped out by the flu and smallpox around 1900. Now, Winter Harbour has only around seventy full-time residents. There is a post office run by early settlers from isolated Cape Scott. There are a dozen or so weathered little houses and a store with a sign that just says "store" because everybody knows who runs it. A few native families live nearby. The ruins of the old clam cannery have long disappeared. The town was hit hard by tidal waves from Chile in 1960 and from Alaska in 1964. The most recent excitement was the seizure of a large amount of hashish on a boat off the mouth of the inlet.

The building in the painting is the Prince Rupert Fishermen's Co-op ice plant and receiving area. The little structure on the right is the fish buying dock. Here, Ron Lynd and his wife buy salmon, cod and halibut from the hundred or so trawlers and gillnetters who work out of the inlet every summer. The fish are then packed in ice and shipped by truck to the home plant in Victoria. These buildings do not have all that much history, but they do look pretty.

In 1969, a gravel access road from Port Hardy was completed. "That," says Bill, "was when the rest of the world joined Winter Harbour."

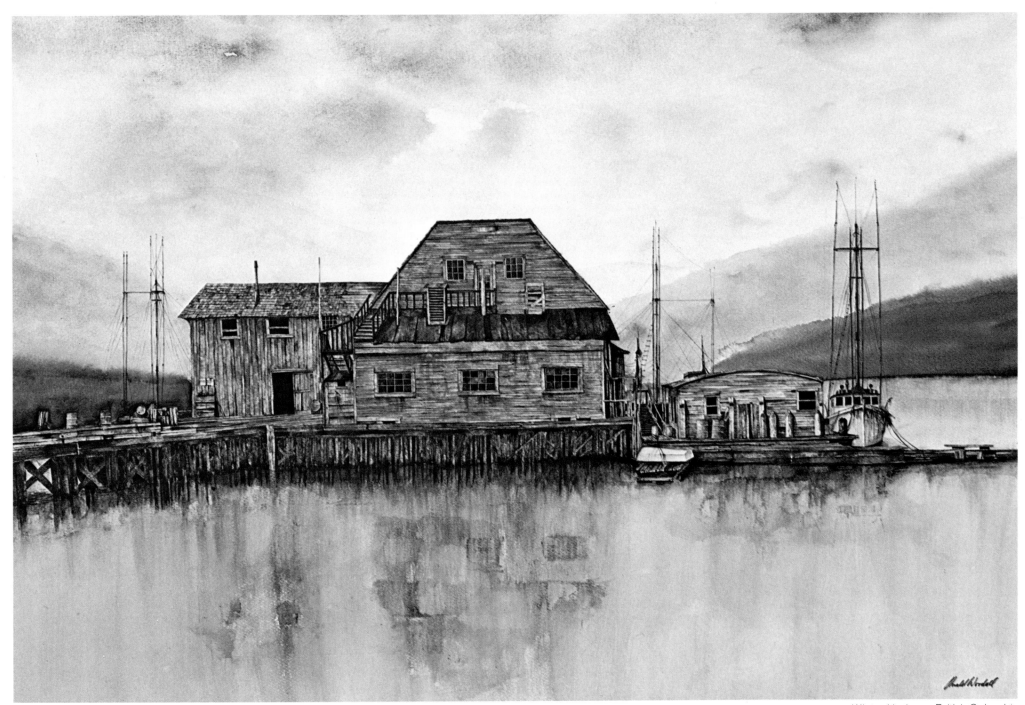

Winter Harbour, British Columbia

The Great Northern Cannery is very special for me because, until 1968, it stood a few hundred feet from where I now live and work in West Vancouver. Jack Shanks, my neighbor, was shore engineer for the fishing fleet. Two doors east lives Fred Hirano, who built the gillnetters for the Japanese-Canadian fishermen who worked for the Great Northern. We live, it seems, on "Cannery Row."

West Vancouver is perhaps the highest priced and most exclusive suburb in Canada. Yet, to this day, it is a strange potpourri of little old ladies in converted summer shacks living beside millionaire stock promoters in architectural showplaces.

The Great Northern Cannery was not the first cannery in West Vancouver. Old-timers will remember the Eagle Harbour operation at the western end of Keith Road. But the Great Northern was the last vestige of any industry in this community that decided as early as the 1930s to be purely residential.

The cannery was built in 1908 by the Defiance Packing Company, named no doubt for Captain Cates' H.M.S. *Defiance* which had, ten years earlier, brought Francis William Caulfeild to Skunk Cove. Caulfeild resolved to create an English country village on the Pacific shore and to this day, Caulfeild's village is a very British enclave with quaint street names like Clovelly Walk and Picadilly. When Caulfeild began to subdivide his estate in 1909, many of the earliest residents were employed at the Great Northern cannery. There were very few other West Vancouverites in those days.

By 1915, the cannery was sold to a man named Sherman, who operated periodically for only a few years before selling out to Francis Millerd, the man with whom most people associate the cannery. He had been prominent in the fishing industry since 1909 and had several canneries in northern British Columbia. He operated the Great Northern only during the fishing season, but from the beginning, the noise and the smell were a problem, and the taxpayers were soon applying pressure to council to refuse renewal of the cannery's waterfront lease. It was World War II that saved the cannery from closure, as round-the-clock operation was required for the war effort. Somehow, it survived to 1967.

I remember how pleasing it was to wander through the old board and batten buildings on the rickety wharves and to marvel at how this relic of another era had survived deep in the heart of modern suburbia. For some reason, I was sure that the buildings would be saved as a chic "Fisherman's Wharf" boutique and restaurant development. But the Great Northern was doomed. At first, there was some talk about a Coast Guard life-saving station. Then the Fisheries Board approached Millerd. And The Honourable Jack Davis, West Vancouver's Member of Parliament, who happened to be the Minister of the Environment, was also interested in the site for his department.

Some fine architectural renderings were displayed, and the local residents were promised a beautiful research complex that would blend handsomely with the surroundings. Even I was convinced that it might be worthwhile to sacrifice one cannery. Instead, the federal government embarked on an austerity plan. Jack Davis was voted out of office, and we were given a collection of mobile laboratories which gave the place the appearance of a trailer park. But however it looks, who can criticize an establishment dedicated to discouraging the dumping of bunker oil and encouraging the love affairs of salmon?

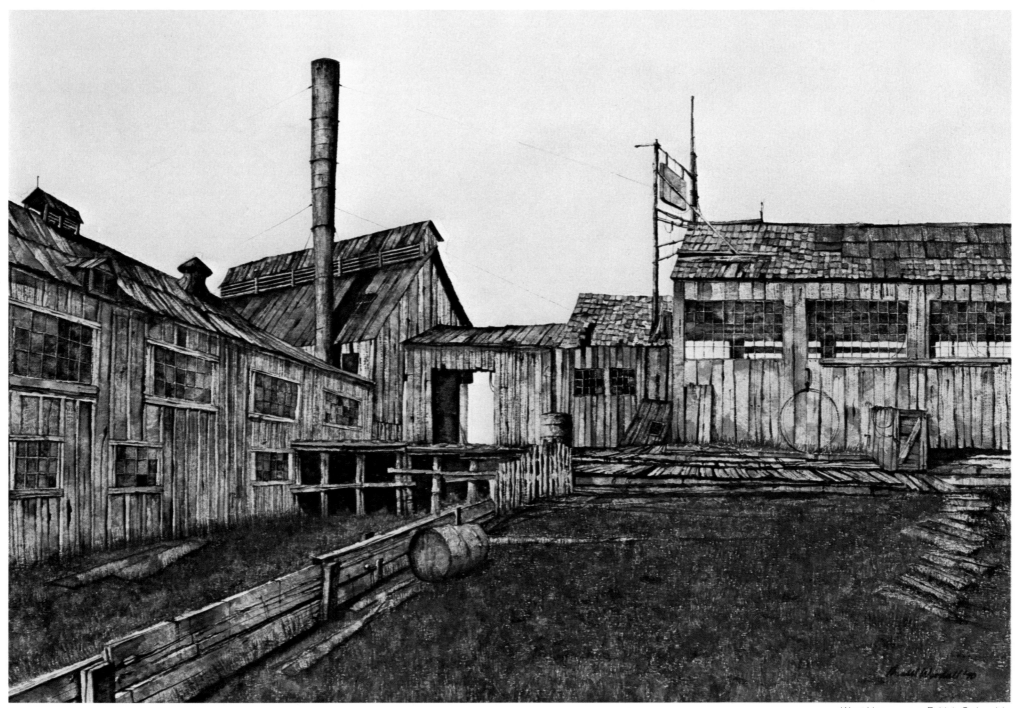

West Vancouver, British Columbia

"When you get off the B.C. Electric car at Steveston, you have stepped into the scented East," reads a 1911 magazine description. Here were 16,000 people, almost equally divided into Chinese, Japanese, Indians and Caucasians, with a sprinkling of Sikhs for good measure, all ethnically pure and quite unassimilated: a worldly community crammed against the Fraser River on Lulu Island. How I would like to have walked the streets of Steveston in 1911!

It all began in the 1870s when the junk-like Japanese boats joined the Cowichan, Cheakalis and Squamish fishermen working the salmon runs at the mouth of the Fraser River. In 1877, Manoah Steves from Moncton began a decade of white settlement on Lulu Island. Then, in the eighties and nineties, the canneries and their Chinese labor began to spread along the riverfront. By 1893, there were fourteen canneries; by 1900, thirty; by 1911, over forty canneries covered the two and a half miles of shoreline and hundreds of great windjammers were unloading their catches at the teeming wharves.

Today, a handful of canneries remain. They are efficient, colorless operations, but somehow, the ghost of old Steveston lingers on. Behind them, there winds a street that is not a street. It is now a narrow strip of knee-high grass bordered by worn wooden sidewalks and the long-abandoned homes and stores of the Japanese fishermen. The faces you see along the waterfront are still mainly oriental and the flavor of the empty ruins is distinctly Eastern.

Canneries intrigue me. They are oversized, crumbling and forlorn. They are like dying giants. Once, they numbered in the hundreds and lined the inlets of the northwest coastal waters. With the coming of refrigeration, the more remote operations began to close down and now, very few remain. Most of the plants comprise buildings of little artistic interest.

The four Steveston buildings shown here are originals and all are part of the Phoenix Cannery complex, one of the oldest survivors in British Columbia, built in 1880 by a Californian named Marshall M. English. At top left is the main Phoenix plant. In 1882, English & Company added a steamship dock and the Phoenix became a hub of activity in Steveston. In the fall of 1890, a salmon syndicate, the Anglo-British Columbia Packing Company, headed by Henry Ogle Bell-Irving, acquired control of seven Fraser River canneries, including the Phoenix. ABC Packing operated it for almost eighty years before selling out to the Canadian Fishing Company, who now market Gold Seal canned salmon.

At upper right is a turn-of-the-century net loft still used by Canfisco crews. The board and batten building is stark and bleached almost white. During the off-season, dozens of Japanese women can be seen mending nets spread across the racks.

At lower left is the Kishi Boatworks, a long and tall 1913 building used for constructing and repairing gillnetters for the Canfisco fleet. In recent years, it has had to be supported by six wooden buttresses. At lower right, is the Britannia Shipyard, the main construction and repair facility for the company fleet. It was originally a cannery and remained one until 1913, which saw the biggest sockeye migration ever. Ironically, that year, the contractors building the Great Northern Pacific Railway line through the Fraser Canyon caused a rock slide which created so narrow and turbulent a cataract that the salmon could not reach their spawning grounds. The effect was felt four years later when the 1913 brood was due to return. It was a disastrous year for the Fraser River canneries. The Britannia never canned again, eleven others closed down, and Steveston's demise had begun.

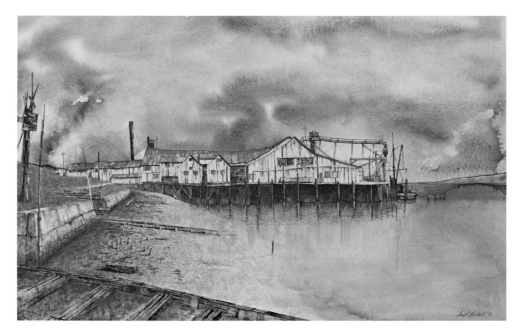

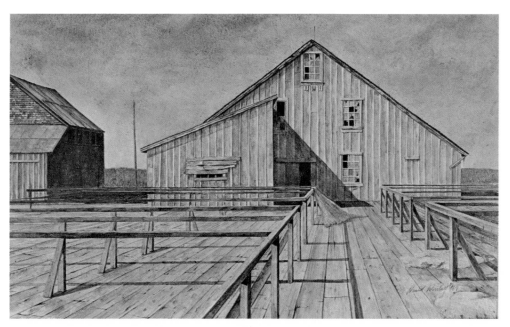

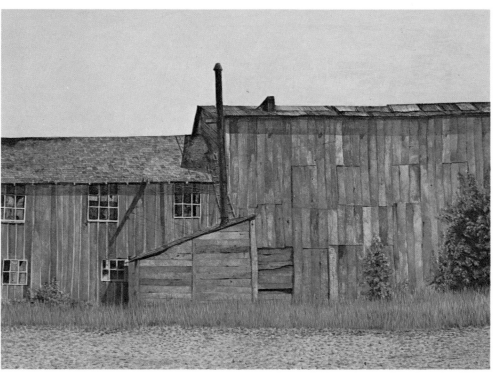

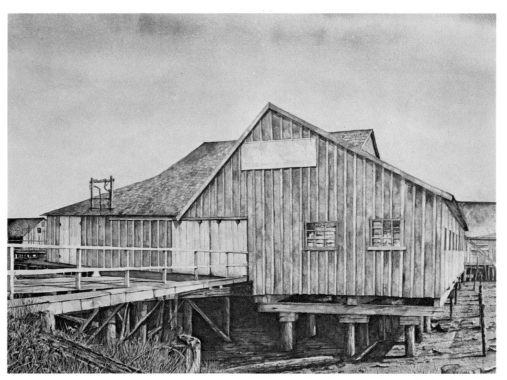

Steveston, British Columbia

In the British Columbia provincial archives, there are photographs of Sandon in the late 1800s. These are pictures of a very big and complete city in which the shoulder-to-shoulder buildings crowd the narrow streets for a mile or so down the steep canyon of Carpenter Creek. Sandon was no scattered shack town. The old street scenes might well have been photographed in Victoria or San Francisco. Sandon was rich and urbane and offered the best of everything in its dozens of first class stores and hotels. For a price, you could enjoy gourmet dining, the finest imported goods, an evening at the opera, or virtually any luxury you might desire. Sandon had electric lights and power, a water system, fire hydrants and sewers. It had a curling rink, a ski jump, and a championship hockey team. For a mining town, Sandon was very sophisticated.

Today, Sandon is a long swath of splintered debris that looks like the aftermath of a tropical hurricane. A few scattered miners' shacks have survived, along with the city hall, a brick general store, and a commercial building called the Virginia Block. But Sandon is gone. It is an eerie and memorable experience to stand among the ruins, particularly if you know the history of Sandon.

In 1892, a prospector named John Harris capsized his canoe while traveling north on Slocan Lake. He decided to head into the mountains on foot and soon staked a claim that was to become the site of Sandon and the capital of the Kootenay strike. There was bitter competition for the rich ore between the smelters in Montana and those being built in Trail and Nelson. Soon, a railway from each direction cut through the forest in an all-out race for Sandon's ore freight business. When the Canadian Pacific won by a day, the frustrated Great Northern crew hitched their engine to the CP station and yanked it into the creek. Sandon burned to the ground on May 3, 1900 when a fire broke out at the opera house. The community rebuilt immediately. It burned again in 1906 and was rebuilt again. But Sandon never regained its glory of the 1890s. There were labor disputes and natural disasters. The railways cut their services. The mines were worked out and finally, silver prices dropped and the miners began to leave for the Klondike. Sandon went into receivership and became a ghost town.

Sandon had a brief revival during World War II. In the hysteria that followed Pearl Harbor, the empty city became an internment camp for Japanese-Canadians from the coast. At war's end, it was abandoned again.

Two events in the mid-fifties dealt death blows to Sandon. Symbolically, the town died when John Harris died. Harris had staked the first claim, led the reconstruction after the fires, owned the rich Reco mine, the finest of the hotels, the most elegant commercial block, and the light and power company. He was the patriarch of Sandon and one of its last citizens. When he died in 1953, he took the spirit of Sandon with him. Then, in 1955, Sandon died physically. Carpenter Creek had always been safely channeled through the culverts that ran under the streets. That spring, with no one left to keep them clear, the culverts blocked and an overpowering runoff from heavy snows carried the city off down the valley, leaving the panorama of wreckage which a visitor finds today.

There is very little left to paint in Sandon. This miner's house was one of the few high ground survivors I found. It probably has an interesting history, but there was no one there to ask.

Sandon, British Columbia

This may be the tiniest gas station on earth. It is in a place called Wilmer, British Columbia, which is an unincorporated community of 280 people a few miles north of the source of the Columbia River in the Windermere Valley.

It was built in 1922 by a lady named Thompson. There was really no need to make it any bigger because Invermere, Wilmer's larger neighbor to the south, had been offering the services of a proper garage since 1915. So the little Wilmer Esso station needed only to dispense fuel for the few cars in Wilmer. It continued to do so until almost 1970 when Jesse Durham, the last dealer, decided that he was too old to pump gas.

The place has changed since I first saw and painted it. The glass pump and the Esso sign have been removed: the pump was sold for five dollars and the sign is in Invermere in the possession of the original gasoline agent for the area. Mrs. Dorothea Dean, who owns the building, has the original glass bulb from the top of the pump. It reads "Esso Premier Imperial Gasoline."

Mrs. Dean is a determined lady who has started an ambitious project in the middle of Wilmer. She has restored the old Delphine Hotel and is just beginning work on the adjoining 1887 saloon.

Mrs. Dean's hotel combines many diverse purposes. It is, of course, a guest lodge, with large and cosy rooms. It is also a gourmet dining salon where Mrs. Dean prepares superb dinners by appointment only. There is in the building an arts and crafts shop which displays the work of local Kootenay artists. And finally, it houses Mrs. Dean's Wilmer School of Quilting, where she teaches her craft to a limited number of students who board at the hotel.

Alongside the hotel she has created a formal tea garden. The tiny gas station has been repainted white and has had a door cut in the back so that it can serve as a quaint utility shed for the tea garden. Presently, it is stacked with gardening tools.

But Dorothea Dean has more plans for the building. She is negotiating to get another glass pump and to recover the original sign. If she can then convince an oil company to get the pump properly installed and running, she will open, believe it or not, the Wilmer Gas Station Museum.

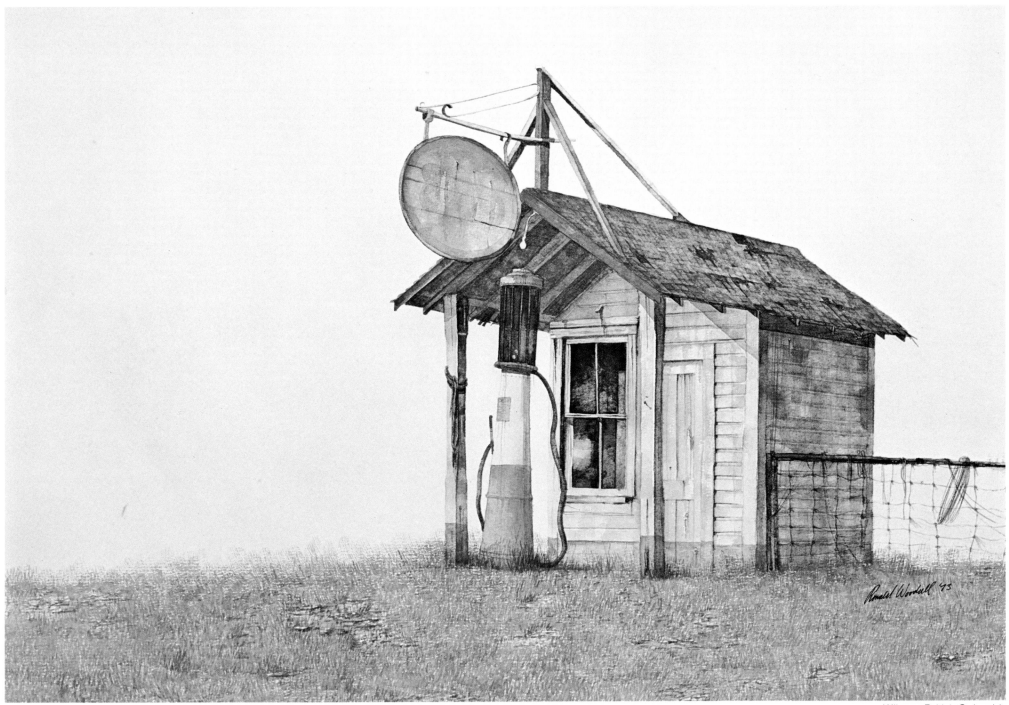

Wilmer, British Columbia

On a day that I remember as being alternately wet and windy but always chilling, I was exploring dirt roads around Yorkton, Saskatchewan, photographing some of the old mud stucco Ukrainian farmhouses scattered throughout that area.

Late in the afternoon, somewhere north of the town of Rhein, I pulled off into an open area, rather like a plaza. There were four buildings in this deserted settlement: a large farmhouse, locked and empty; a huge shed that looked as though it might have once been a feed dealer's building; a rusty ochre general store, and a filling station with a funny stepped false front. The fourth building, the one that dominated the square, was an immense Ukrainian onion-domed cathedral, well kept but apparently no longer used.

My detailed area map indicated that I was in the community of Dneipers. I did a little photography, took a few notes, and, having run out of light, returned to Yorkton.

Back home, I finally decided to paint the little garage, so I wrote to Dneipers seeking some information about the odd grouping of buildings around the square. The Saskatchewan post office informed me that there is no such place as Dneipers. Then I wrote to Rhein and described the buildings just up the road. Nobody at Rhein knew what I was talking about.

It must have been a dream.

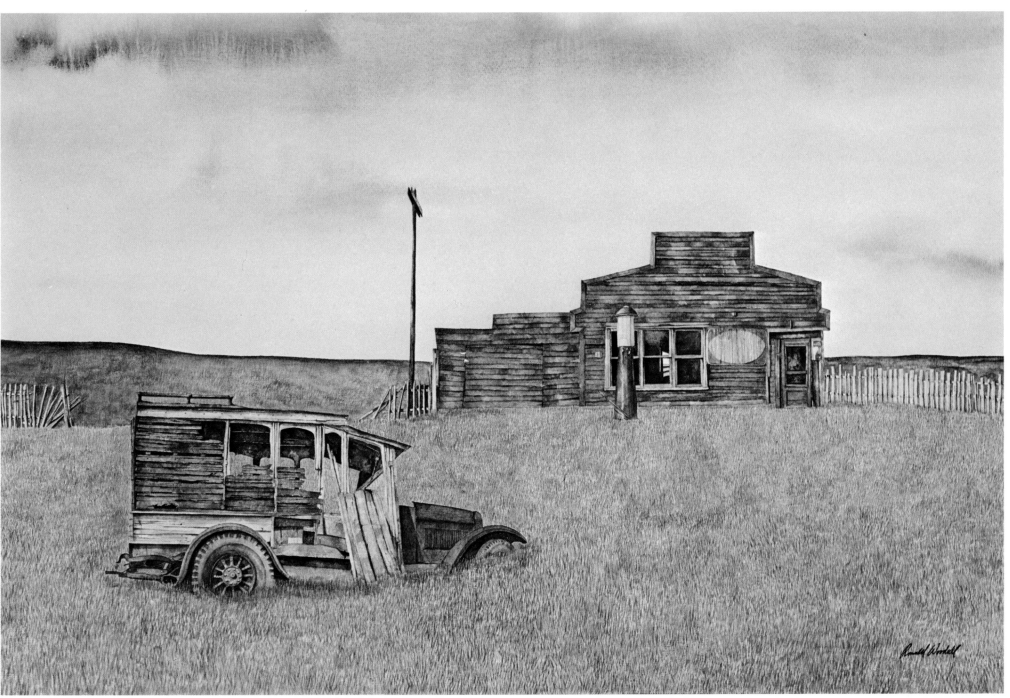

Dneipers, Saskatchewan

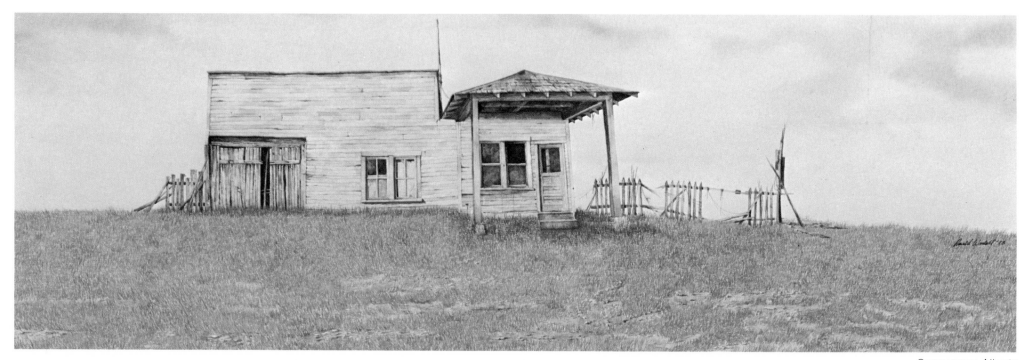

Carmangay. Alberta

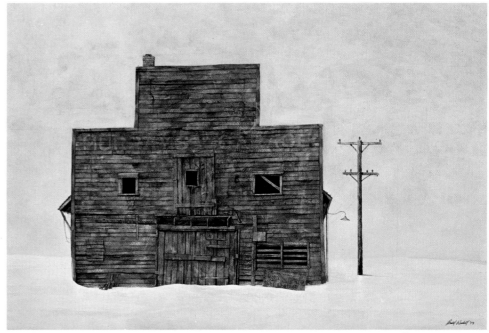

Rosebud, Alberta

Old garages come in all shapes and sizes. Here are three more that we have come across.

The one at top right is Murray's Garage in Rosebud, Alberta, where A. Y. Jackson, the Group of Seven painter, used to go to get away from it all. So we went to take a look at Rosebud. The best thing there was Murray's Garage. It was pink, which seemed a lovely color for a garage in a place called Rosebud, don't you think?

At bottom right is the Trout Lake Esso Service. Trout Lake City was the capital of the Lardeau district mining activity in the Kootenay area of British Columbia at the turn of the century. Today, there is very little left of Trout Lake City. My favorite survivor is this gas station. It has that ugly between-the-wars boxy anonymity which is so bad, it's great!

At left is a fine and simple thirties vintage prairie garage that we spotted near Carmangay, a little town thirty-five miles north of Lethbridge, Alberta. At one point it had been converted into someone's home. Some tattered curtains still hung in a few of the rear windows. Now it has been returned to the status of ex-garage. I find this a very pleasing building. It has a lean and hungry look.

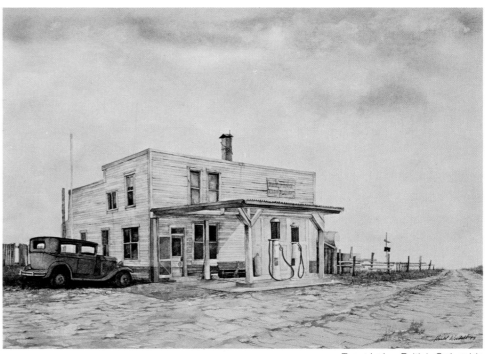

Trout Lake, British Columbia

Here is a classic prairie false front. Such elegant uglies line the main streets of rural towns across western North America. The false front attempted to disguise the frontier shed by simulating a more substantial city building. A full street of joined false fronts gave a citified eastern feel to a pioneer shack town.

This old rambler is in Brock, Saskatchewan, a little dot of a place in the middle of the wheatfields, somewhere between Drumheller and Saskatoon. It is remarkable how a simple structure like this one could have gone through such a complex evolution of shape, use and ownership. It began as two separate buildings. Early in 1910, two gentlemen named Burns and Stewart from Emerson, Manitoba, moved to Brock. They built the smaller structure on the left, with the wide garage doors. There they established a Ford Motor dealership, one of the earliest in the area, and an International Harvester farm machinery agency. The next year, a man named Moore, who had been running a successful bakery shop up the street, decided to expand. So he built the two-story false front, moved his family upstairs, and combined his new bakery operation with a restaurant.

Then came World War I. By 1913, Stewart had sold his interest in the garage to Burns, and Moore had rented the bakery and restaurant to Ab Gregor. A few months later, Gregor was gone and the business was sold to the Rymal family, whose restaurant and rooming house had just burned down. Rymal sold to William Cyr, who added a grocery store. Cyr sold out to a man named Delarue, and before the decade was out, Tom Fleming took over to become the building's seventh proprietor. Then it stood empty for a couple of years before being revived as the Brock Pentecostal Church whose following,

under the Reverend Mr. Scherk, became large and prosperous. But almost as quickly, interest in churchly matters waned, and within eighteen months the building was empty again.

In the meantime, Burns had sold his garage to Foster and Ralph Pomeroy who, three years later, sold it to Alf Gandy. Gandy and his son then decided to buy the abandoned false front and consolidate their holdings by connecting the two buildings with a third section. By early 1925, the buildings had become the single structure that survives today. Gandy & Son then opened a hardware store in the false front, but more importantly, they began an enterprise that changed the life-style of Brock. Sometime in 1929, they imported a one-cylinder stationary diesel engine from England and installed it at the back of the store. On February 1, 1930, the first electric power flowed into the homes of Brock. The plant started up an hour before sundown and ran until midnight. Brock became a town of Cinderellas who scurried home from visits and socials before the lights went out. Monday and Tuesday mornings, power was available from nine until noon, but the demand was so great that it barely heated an electric iron.

The place had two more owners. Art Wilford, whose name is still on the building, bought out Gandy in 1945 and then sold again to F. P. Kelly in 1953. Three years later, Kelly joined forces with a brother-in-law named Fryhrman and the operation was moved to Fryhrman's property. So, sixteen proprietors later, the old bakery-restaurant-grocery-garage-machinery agency-Pentecostal church-hardware store-electric company has finally become a storage shed, and such it will probably remain.

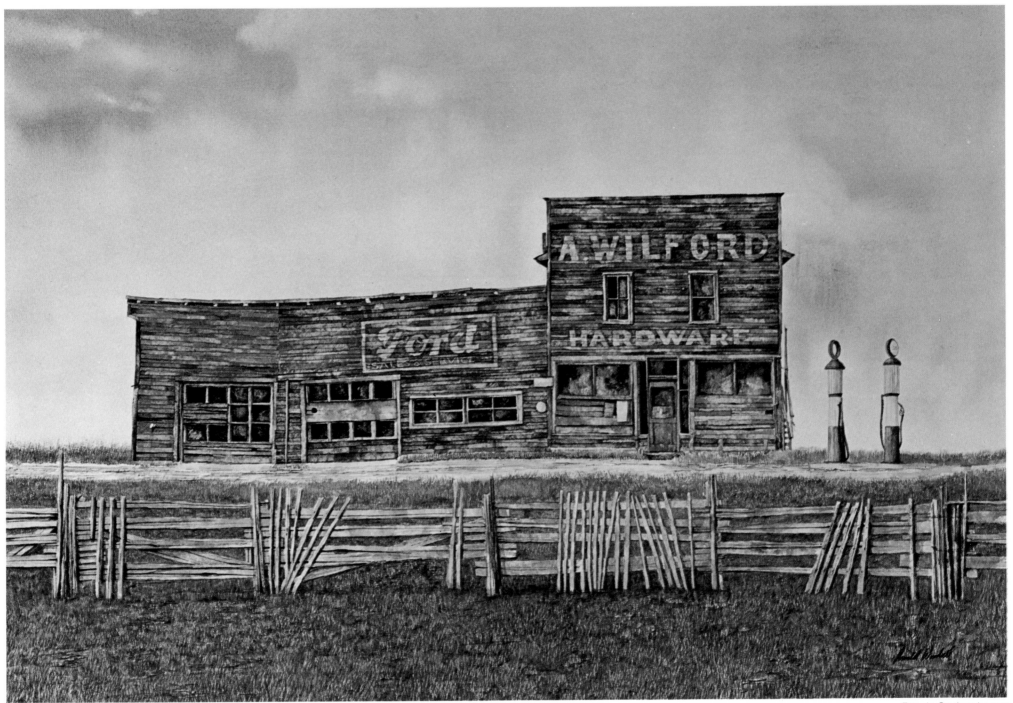

Brock, Saskatchewan

A group of doctors who had taken some interest in my work invited me to have a small showing at a reception they were holding. That evening, a young cardiovascular specialist named Tom Godwin asked if I would be interested in doing a painting of the barn on his farm in Surrey, British Columbia. I told him it depended on the barn.

A few weekends later, our two families were slogging through the gooey spring mud on Tom's forty acres. We negotiated a flooded brook and, looking through a grove of tall trees, got our first glimpse of the Godwin barn. Its most striking feature was the unusual coloration. Unfortunately, the painting does not do it justice. The Fraser Valley tends to be damp and rainy and over the years, the whitewashed siding had taken on a patina from the embedded moss which glazed the entire building a rich ochre green. A thicker deposit of roof moss had permanently stained the large cedar roof shakes. The building was proportionately pleasing, too. It was higher at one end, rather like a big ship under full steam. The black openings of the windows and the loft doors were broken attractively by horizontal gate boards. And, unusual for a western barn, there were six somewhat uneven small-paned windows running the length of the livestock shed, one facing each stall. The barn was supported by massive 10 by 10 king posts and tie beams with un-trimmed rafters and ridgepole. The entire interior of the building was whitewashed.

It was built in 1899 by George Atchison, a pioneer valley farmer, soon after he arrived from Pembroke, Ontario. He searched the entire Fraser Valley before deciding on this area of Surrey called Tynehead and then he chose this site on what was called the Coast Meridian Road as the place to raise his family. A few years later, he built a gracious homestead for his wife and eleven children. The house, or parts of it, still stand today. It has been moved and now faces a different direction; it has been lowered; and it has been stripped of its wide balconies, but the chimney and corner cornices identify it as the original structure in the archives photograph.

A return visit to the old barn convinced me that it has very few years left unless the Godwins undertake some major steps to preserve it. The lower wallboards have rotted and the roof shakes are peeling away. The lean-to stock shed has collapsed with last winter's snowfalls. More siding has dropped off, more windows are broken, and the huge wagon doors on the east face have vanished.

The Godwins now house their livestock in two ugly but functional plywood sheds with metal roofs. We brought our children inside one of these to see the litter that a gigantic sow had just delivered. Two stillborn piglets had been left on the concrete floor. I covered them with a plastic bucket. As much as I like barns, I would not make a good farmer.

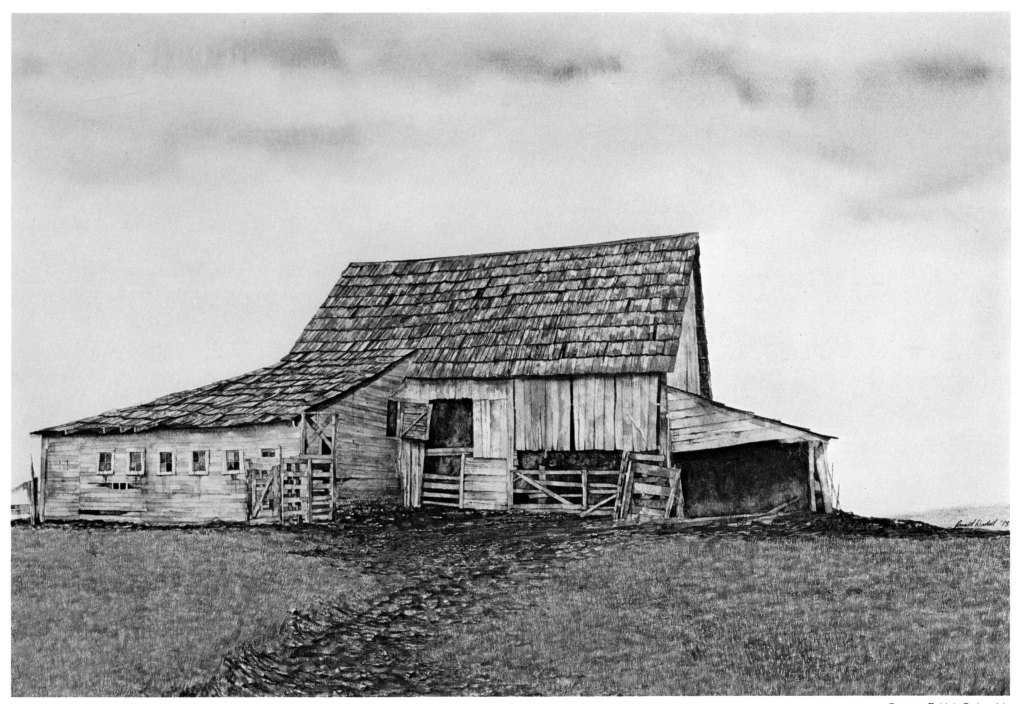

Surrey, British Columbia

We saw this building first by moonlight on another of those evenings when we had pushed our luck, hoping to delay the sunset. In that light, it was unbelievably ghostly. As I tried to find my way around in the darkness, I was startled by inquisitive cattle. Visions of angry bulls made me decide to return in daylight.

It was more than a year before we went back, accompanied by Vic Scott who owned the adjacent property. We had been staying at Vic's guest ranch and I was helping him measure, for insurance claims, the remains of three of his ranch buildings which had burned. Vic knew nothing about the building in the painting except that it had been long abandoned. We went inside. Judging from the amount of interior weathering, it must have been empty for decades. The walls throughout were narrow V-joint and finely finished. In the main sitting room, there remained an ancient Clave Jewel wood stove. A cramped, enclosed stairwell led to five second-floor sleeping rooms, in one of which was a homemade four-poster bed. Every door and window frame was embellished with decorative hand-carving. Everywhere, the floor was so worn that the knots had become high, shiny bumps.

Behind the building was a great complex of rough-hewn structures which Vic told me was known as the Pigeon Ranch. He showed me the old ranch house, built of adzed logs, square cut and dovetailed, which had a mud roof with grass sod binding. The floor was deep in manure from wintering horses and the cardboard walls were peppered with bullet holes. Then Vic took me into the cold cellar, a clay-walled labyrinth burrowed into a monumental pile of dried mud. From there, we went to the old slaughterhouse — an ugly place. The livestock had been run into a corral, shot in the head, and shoved through a hole onto the butchering floor, where they were hoisted aloft on a big wooden wheel. The wheel is still there, broken and lying among dried carcasses and skins — and flies. It looks like an old torture chamber.

We measured the charred foundations of Vic's buildings, which had comprised a log barn, a two-story log bunkhouse, and an old saw-mill. He told me that they had been fine buildings and that it was a pity I had missed them. A movie company had been considering them for a film location.

On the way back to Vancouver, I dropped in on Avis Choate, who runs the historical museum in Clinton. I asked her what she knew about the old building fifteen miles up the Gang Ranch Road. Her eyes lit up. "That was Cataline's place. He built it for his mule teams and drivers."

Jean Caux, a Basque known as Cataline, was British Columbia's most famous packer for over fifty years. He ran mule teams from Yale to Barkerville during the Cariboo gold rush and as far as Hazelton in later years. Cataline built the place about 1858, the year he started packing to the Cariboo. "He never owned land," Mrs. Choate explained, "He just built places to rest his freight teams." That probably explains why his waystop and stable are completely surrounded by the ranch buildings of the Pigeon family who arrived from Quebec in 1860 seeking gold but stayed to homestead. After many generations, Cataline's building is still owned by the family and is presently registered to Rossier Pigeon, who, being too old to ranch, rents out his pasture land.

Mrs. Choate's information must be true. It comes straight from Judge Henry Castillou, whose father bred Cataline's big mules and often took shifts on the pack trains. It is a pity that so historically important a building has been abandoned to the elements.

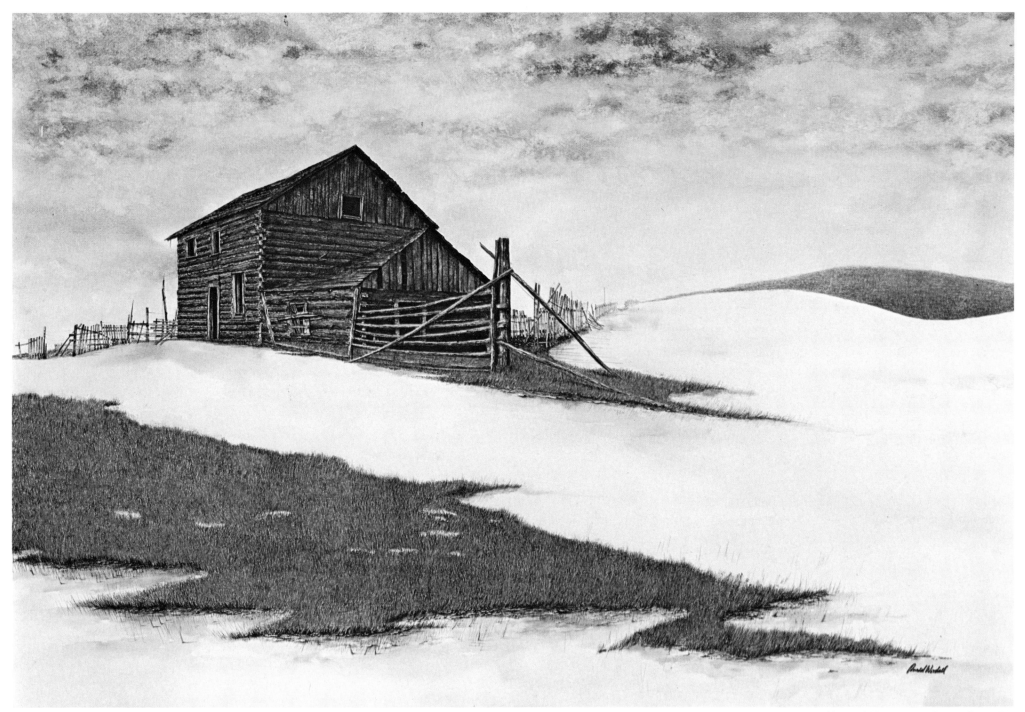

Near 70 Mile House, British Columbia

Some buildings tease my curiosity unmercifully. On the delta south of Vancouver, British Columbia, a river road doglegs through a tiny group of buildings huddled around a triangular potato patch like an island of frozen time holding back an onrushing tide of subdivision. The big hand-painted letters on the corner farmhouse read: CHUNG CHUCK POTATO GROWER. Across the field, up on the flood dike beside the river, a classic western false front sits isolated against the sky. Having painted both buildings, I thought it would be an interesting idea to find Mr. Chuck.

He was working in the field, but soon we were sitting at his kitchen table where he had invited me to share a buttered corn-on-the-cob lunch. Outgoing, spry and warmly hospitable, Chung Chuck is a lively young man of about eighty. He places his arrival in Vancouver around 1909, when he was in his mid-teens. "I'm the last one," he grins; "all the rest are dead. Must know something they didn't."

There had been 350 Orientals living in the community which clustered around the corner he farms. The Japanese were taken away during World War II, and never returned. The Chinese, young men brought in to build the railroad and work the canneries, grew old long before the immigration laws would allow them to import wives, so they died without families. Now, there is only Chung Chuck left. He lives with his daughters in a one-time Japanese res-

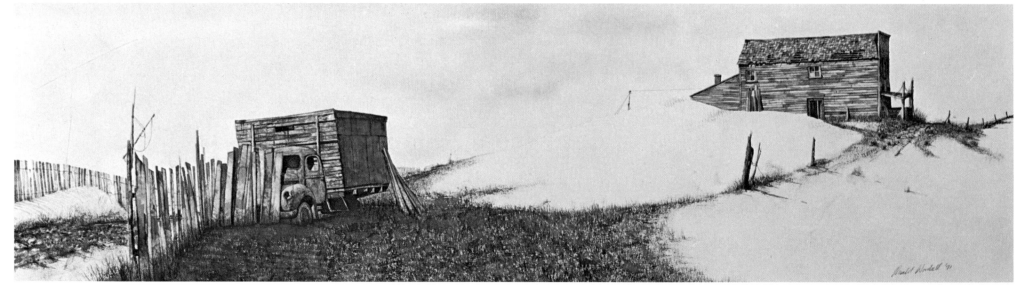

Ladner, British Columbia

taurant between the farmhouse and the false front. This building, his current home, is a living museum. There is not a square inch of wall or floor that is not covered with personal memorabilia. The main room still contains the original shelving and counters from the restaurant. These shelves are stacked with law books, and herein lies an interesting story.

The Oriental pioneers often received questionable treatment in the courts. Chung Chuck decided that they needed someone they could trust to defend them. So he became an unoffical storefront lawyer and began his lifelong study of the Canadian criminal code. He claims to have been to court 800 times and to have forced a case to the Privy Council, testing the constitutionality of the British North America Act. What's more, he *won*. He also claims to have gone to jail six times for his activities.

Of the buildings themselves, the most fascinating is the old false front which is the only survivor of the dirt "main street" which ran along the dike. Originally, the backs hung over the river and the hodgepodge of colorful sheds and rickety wharves provided a memorable sight for the ferry passengers coming upriver from Steveston.

Now, there are real estate signs everywhere. "Waterfront acreage," they read, which is not as nice as Chung Chuck's earlier "For Sale 2 Peaces." The other day, I walked along the dike again. There was a delicious smell of something frying coming from the false front where a million-year-old man was cooking on a black iron stove. Chung Chuck was digging an irrigation ditch in the potato patch. We just waved. I remembered his saying that he would retire soon. "Going to go to Hong Kong. Or maybe San Francisco. Or maybe New York." He won't like New York.

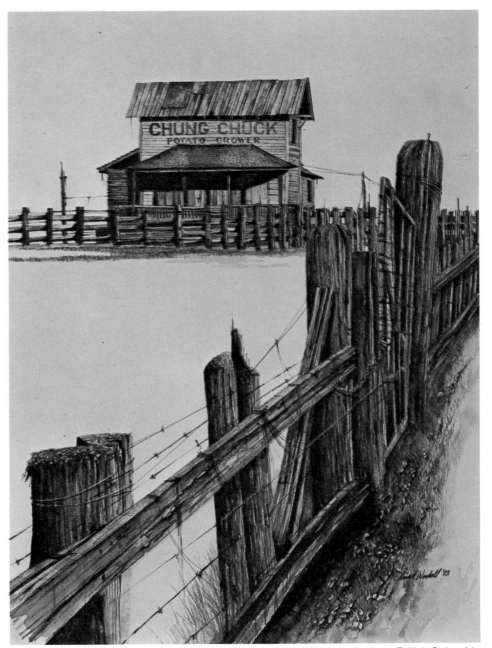

Ladner, British Columbia

This tiny fairytale general store in Silver City, Idaho, is folk architecture in its purest sense. About 1875, amid the hardships and callousness of a wide open mining camp, some anonymous carpenter with humor and inventiveness used his scraps and end cuttings to fashion a rough simulation of old country stone carving. The practice was called "Carpenter Gothic" and this was a very primitive expression of that craft. Perhaps it was an attempt to bring a touch of San Francisco to the mountain wilderness: Nob Hill on a tight budget. Perhaps it was an expression of optimism, or flamboyance, or mere decorative playfulness, but whatever possessed that carpenter, his instinct for ornamentation was fresh and delicate and graceful and, oddly enough, less repressed than that shown by tradesmen in today's enlightened times.

The carpenter was undoubtedly a European craftsman, and probably German. Silver City had a sizable population of German fortune seekers. It is possible that he had been a stone sculptor who, forced to abandon his chisel for a hammer and saw, refused to abandon his craft. Whoever he was, he left a joyful little legacy up there on War Eagle Mountain, and we should applaud his motives.

Silver City may be the purest ghost town in North America. No one has protected it or restored it. It is too remote and far too difficult to reach ever to be commercialized. It has not had a major fire. And, most important, it has a handful of residents left who are willing to be vigilant caretakers.

Though the community is hidden high in the Owyhee Mountains south of Boise, it was laid out carefully and in an orderly manner, as if by an urban planning department. At the center of town, there is an open plaza which, incidentally, has a mine shaft in the middle of it. There are a couple of comfortable wide-balconied old hotels. On the main door of the Idaho Hotel and Annex, which takes guests despite the fact that it has been condemned, there is a sign which warns: "No animals, rowdy persons, or self-propelled vehicles." A giant Masonic Hall straddles a creek called the Jordan, and naturally there is a local joke that any lodge member who walks the length of the lodge has "crossed the Jordan." There are some saloons, a newspaper office, a spectacular hilltop church which has been both Protestant and Catholic at various times, the remains of a red light district, an old Chinese laundry, the stone ruins of a bank and courthouse, and six intact streets of authentic ghost town architecture.

Once again, I must apologize for taking a slight liberty in isolating the little store in the painting. At Silver City, it is crammed tightly between two large buildings: The Lippencott Mercantile Building and a big saloon.

We met a couple in Silver City who had decided to leave teaching careers in an eastern university to settle with their young family in this old town. They had restored the historic Silver Slipper Saloon as a sandwich and ice cream parlor catering to summer visitors and were preparing for their first long winter of utter isolation. We were discussing the merits of various ghost mining towns and exchanging opinions on which had been, in one way or another, spoiled. Our host paused for a second, and then made a comment which described perfectly the collection of folksy fretwork gingerbread that is Silver City. "This place," he said in distinct New Yorkese, "is Kosher."

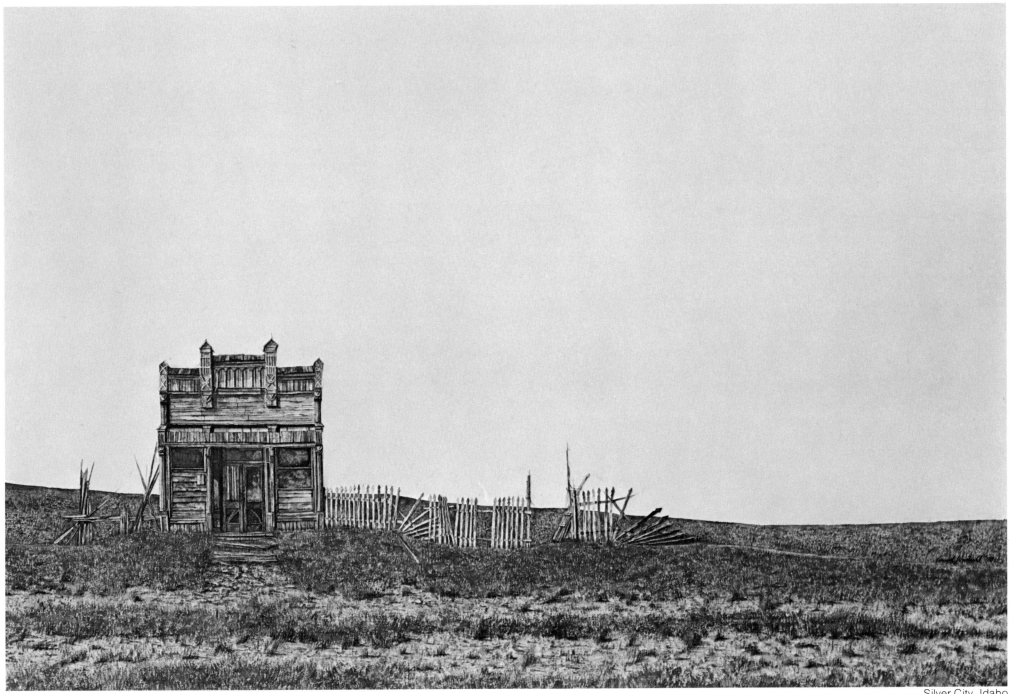

Silver City, Idaho

This barn has probably been seen at one time or another by most Vancouverites. It stood beside the Squamish River at Brackendale, and for anyone driving to Alice Lake Provincial Park or farther on to the Whistler Mountain ski area, it was probably the only barn they noticed. It would be interesting to know how many realized that it quite unceremoniously disappeared sometime in late 1973.

As British Columbia barns go, this one was quite grand. It had a board and batten exterior, a big cupola, and long, low eaves broken only by the gabled wagon door.

In the late 1890s, three physicians from Vancouver acquired a one-section grant of flatland and mountainside in the Squamish Valley. While this may come as a surprise to some around Vancouver, Squamish was a rich hop-growing area and there was a strong demand for Squamish hops, particularly from breweries in Germany. So when the land was finally cleared, the doctors hired a family named Thorn to plant hops and run the ranch. In 1911, Mr. Thorn, well financed by his employers, built this extraordinarily fine barn and a ranch house. When war broke out in 1914, the European market disappeared and the operation turned to mixed farming. While few local people remember specifics, it seems that the property passed into the hands of a family named Carson and that the farmhouse burned about 1933. After a period of inactivity, the ranch was taken over in 1939 by MacKenzie and Company as a pig farm, there being a pressing demand for pork during the war years. After the war, the land was leased for grazing.

The ranch looks quite different today. Across the road from where the barn stood is a small shopping center called Eagle Run Village: a laundromat, a bakery, a building supply store, a grocery and a beauty salon. Behind the shopping center is a massive housing tract developed by the current owner.

Where the barn stood, there are a few smashed cattle stalls standing among the rubble and the rotted sill timbers. Nearby, six Ayrshire cattle graze near an old moss-covered livestock shelter, but the smooth pasture to the edge of the Squamish River has been obliterated by a recently constructed earth dike built to protect the flatland from spring flooding.

The barn was obviously a local landmark and I have noticed several sketches of it in local stores and offices, and three renditions by three different painters in a little art gallery up the road. A Brackendale lady told me that there was some mild dismay shown when demolition began, but most local residents accepted the fact that it had decayed beyond salvation and was probably a hazard. Despite many queries, the whereabouts of the big posts and beams and the elegant cupola are still a mystery. The way it was told to me, the big lumber pile "just kinda dwindled away."

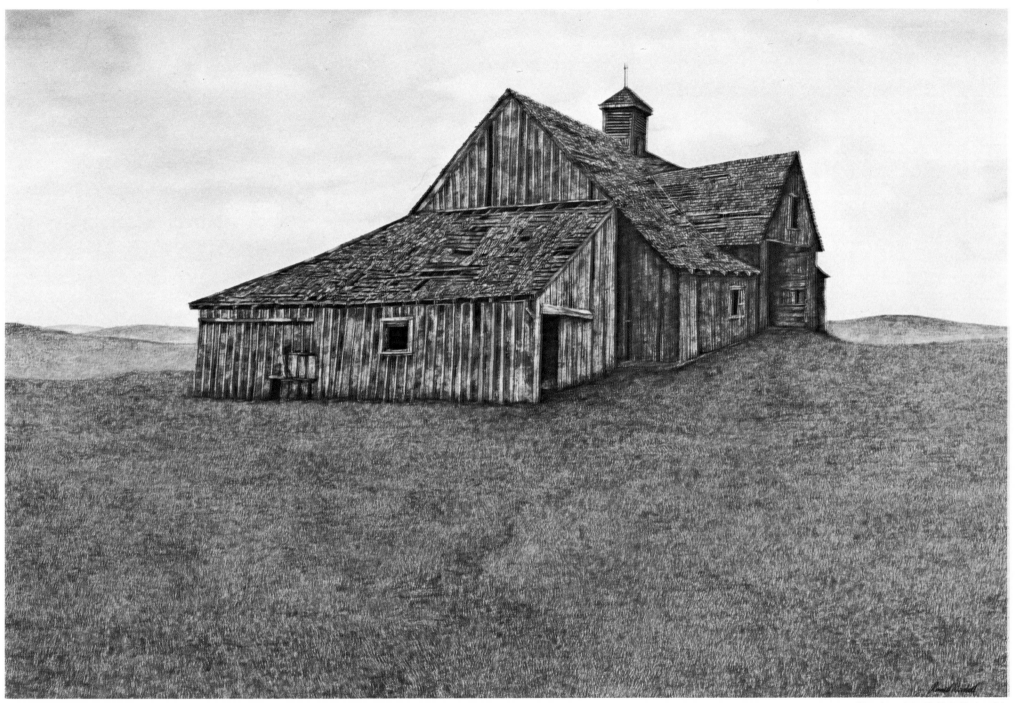

Brackendale, British Columbia

Since my arrival in British Columbia, I had been hearing about the Douglas Lake Cattle Company, a ranch almost as big as Prince Edward Island. So when we saw the sign on the dirt road, just north of Quilchena, we decided to take a look.

Canada's largest cattle empire, the famous Three Bar brand, is headquartered on land homesteaded by John Douglas in 1872. In the 1880s, the spread supplied meat to the construction crews cutting the Canadian Pacific Railway through the mountains.

For some reason, I expected to find a grand collection of old hand-hewn buildings just begging to become paintings. Instead, Douglas Lake proved to be a crisp and efficient modern ranching operation and I must admit to driving by this sprawling red and white complex without taking too close a look. A little farther down the road, at the Spahomin Indian village, I spotted a barn that was a little more to my liking. The siding seemed to have absorbed all the tones of the winter landscape and the planked roof had retained a light cover of windblown snow. On the lean-to wagon shed at one end, two small gables were built over the doors and looked like raised eyebrows. I decided to paint the barn from that angle.

Nina Woolliams, whose husband Neil manages the Douglas Lake Cattle Company, was kind enough to supply me a little information on the building. Spahomin village stands at the edge of Douglas Lake itself. Here, the barn was built in the year 1900 by Chief Alexander Chillihitzia to house his horses and cows. It is now owned by his aged niece and has stood unused for years. A friend of mine, who drove the Douglas Lake road last autumn, showed me a photograph he took of the barn. The entire end wall above the two gables has been stripped away and the building looks as though it will very soon disappear into the bunch grass.

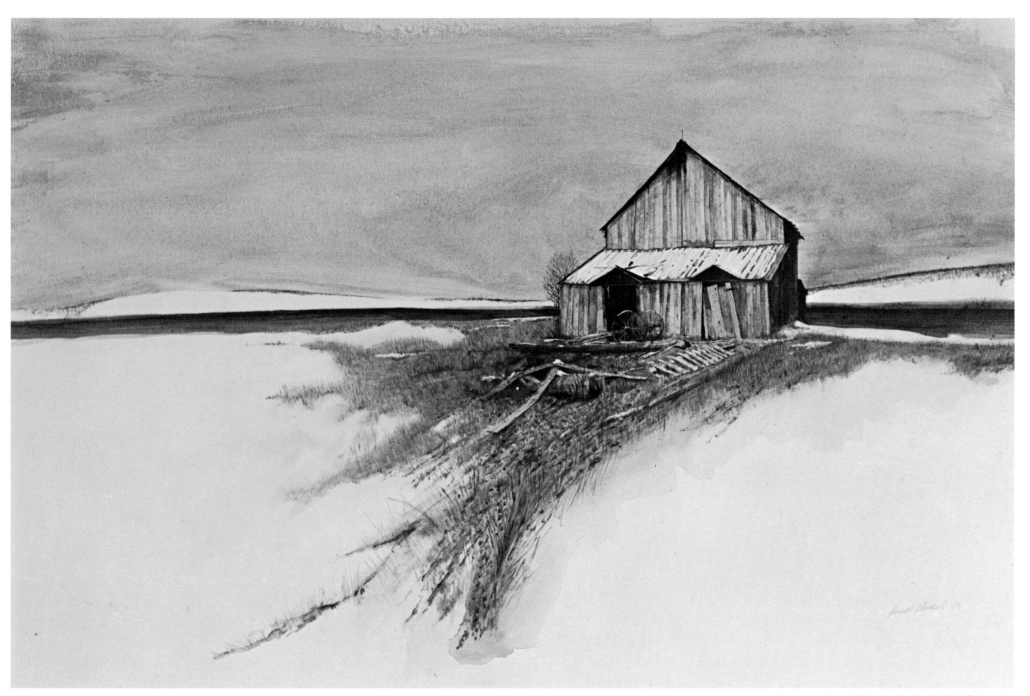

Douglas Lake, British Columbia

This large, lone ranch house at right is near Pritchard, British Columbia in the high and dry grazing lands of the Douglas Plateau, southeast of Kamloops. This is cattle country, and as long as I can remember, the building has been used to store hay for winter feed. The place has been empty so long that the whereabouts of the family that built and lived in the house remains a mystery to the local ranchers. Neighbors remember only that the spread was homesteaded about 1897 by a group of Flemish settlers. A small grave marker on the hill behind the farm testifies to the tragedy of a child who drowned in one of the watering holes sometime early in the century.

This is one of those favorite buildings that I have painted many times. What attracted me most was the maze of rickety lean-tos and balconies and little half-collapsed woodsheds that had accumulated over the years. They gave the building a complex but pleasing form, and a special personality.

On the following page is another painting of the same house as I found it three years later. I should have known that those lovely bits and pieces would have been stripped away, probably for firewood. While not as interesting as it had been earlier, the side view now presented an impressive simplicity, so I painted it again. The most foreboding change was the sign nailed to the wall, advertising the property for subdivision into "ranchettes." Recent provincial restrictions on farm land development may have changed that, but it seems a pretty good bet that the next trip to the Douglas Plateau will find this ranch house gone.

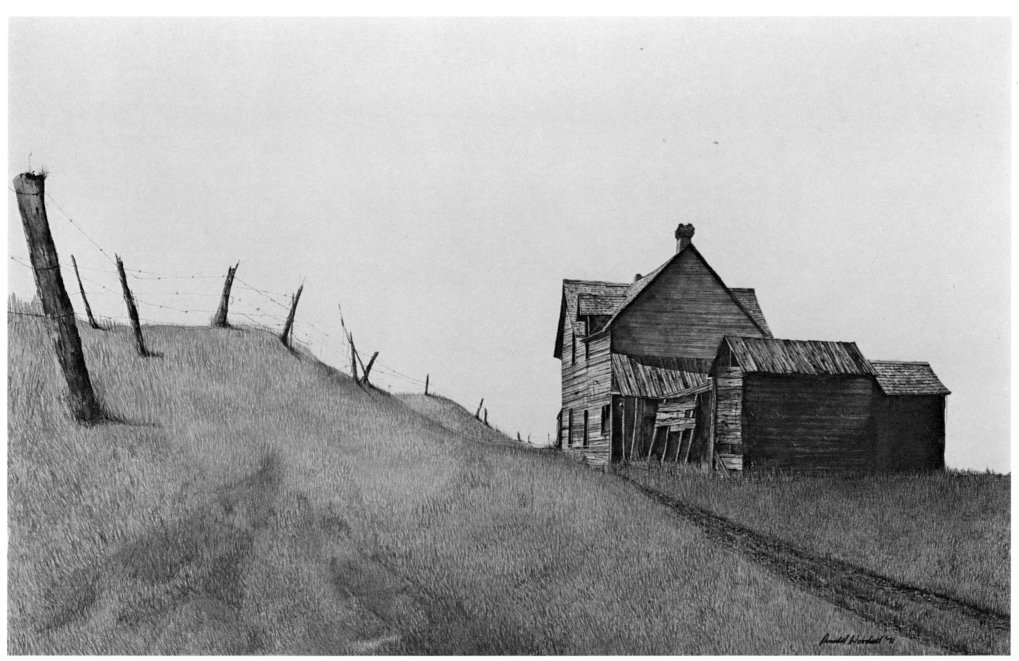

Near Pritchard, British Columbia

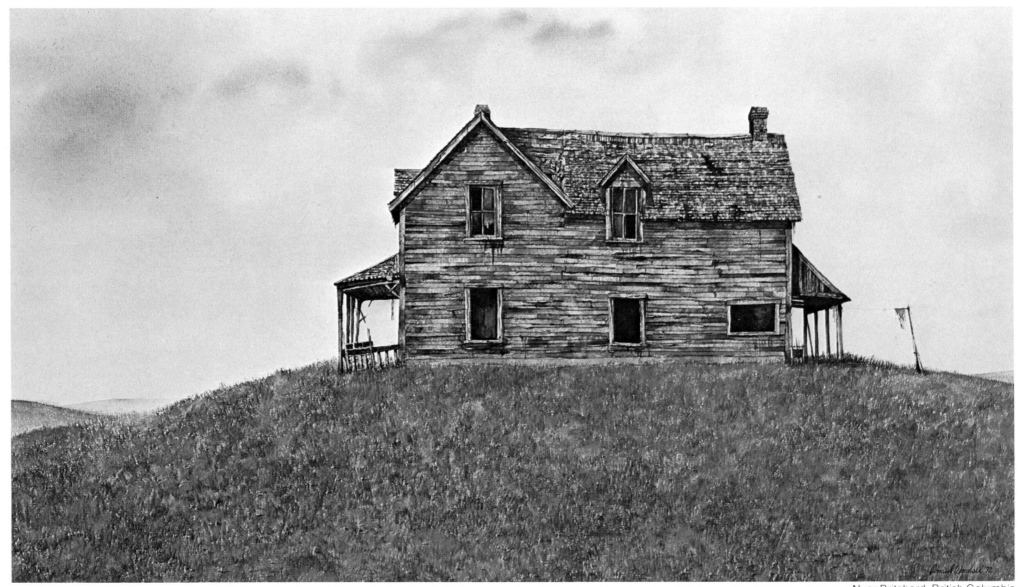

Near Pritchard, British Columbia

The paintings on the following five pages are a series commissioned by Building Products of Canada for their fiftieth anniversary and were completed just prior to my beginning this book. Working closely with Heritage Canada and the Royal Architectural Institute of Canada, the company sought to demonstrate the fact that there is inherent historical value in even the simplest examples of indigenous rural domestic architecture across Canada. The company reproduced the original paintings in a limited print series and presented the reproductions to every architectural firm in the country.

Obviously, I needed no convincing of the rightness of the company's philosophy and was delighted to take on the assignment. We decided to explore five geographical regions of Canada — Quebec, Ontario, British Columbia, and the Atlantic and prairie provinces — to find five farmhouses which typified the early shelters built by the pioneer farmers of each region. Finding the vernacular dwelling is not as easy as it sounds, for I soon realized that they were all different. After delighting for years in the fact that no two country buildings are quite alike, I experienced a problem on this assignment because of their differences. Finally, after spending too many days driving too many miles, I settled for five buildings that were certainly indigenous, but I will not argue that they are the most typical.

Included with each painting are some general impressions I felt about the region and its rural architecture. As generalizations, these observations hardly apply to all of the buildings of the area, but the way a farmhouse is built reveals much about its history, the economy of its time, and even the aspirations of its owners.

Finding a building to represent Atlantic Canada was the most difficult of all because Nova Scotia, New Brunswick, Prince Edward Island and Newfoundland are so different. I chose Newfoundland because it was the easternmost.

The houses of Newfoundland are square: simple boxes with flat roofs, perpendicular and functional and virtually identical, and built with an economy that excludes adornment. Individuality is expressed with color, sometimes bright and brave, sometimes subtle and conservative. The paint which fights the cold salt air seems a hundred coats thick. Though unpretentious, Newfoundland's houses are nevertheless trim and crisp. Their haphazard siting and criss-cross mazes of driftwood fencing turn each outport hillside into a superb tapestry.

This house and stable are on a small farm overlooking Conception Bay. Most buildings are two-tone like this one. The combination of gray with red seemed a popular one. The red trim, I was told, is a home-brewed, weather-resistant paint made of metal oxide and fish oil. It sounds possible, but it could be that somebody was having a little joke at the expense of this mainlander.

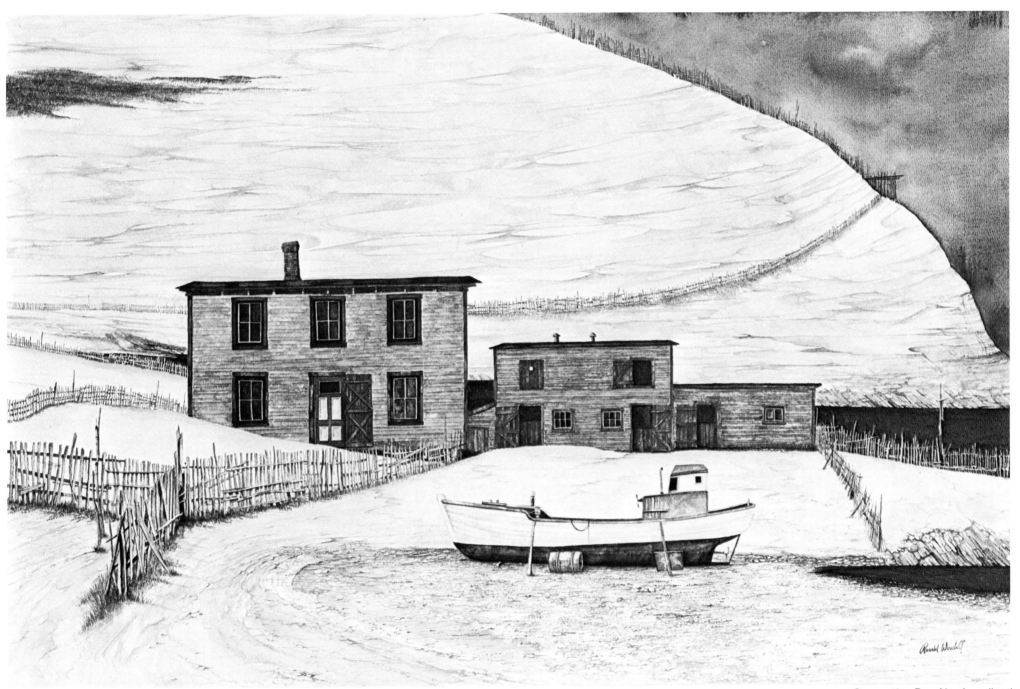

Conception Bay, Newfoundland

Quebec is so rich in barns and farmhouses that are beautiful to see and paint that it almost takes the fun out of hunting. I remember one very cold winter evening, standing on Isle D'Orleans, watching the sun set over the ramparts of Quebec City. The snow was blowing off the St. Lawrence ice jam and my Vancouver bones were frozen brittle. It occurred to me that I had that day seen so many picture card villages and candy-coated farmhouses that I could not remember one I wanted to paint. I liked everything but loved nothing. Finding subjects to paint in Quebec is like choosing from a tray of French pastry.

Quebec farmhouses are happy looking buildings, warm and informal, promising comfort and hospitality inside. They are sociable buildings, close to roads and passersby. They are front porch homes, designed to be lived around as well as in, with privacy and isolation given low priorities. They are feminine, graceful, romantic, curvaceous and sensual. They are genteel and artistic. They are high architectural folk art. This building is on historic Rue Royale in old L'Ange-Gardien, east of Quebec City. It is a classic artisan house and is actually in a town but so surrounded by distracting elements, I decided to give it a little breathing room. Je regrette.

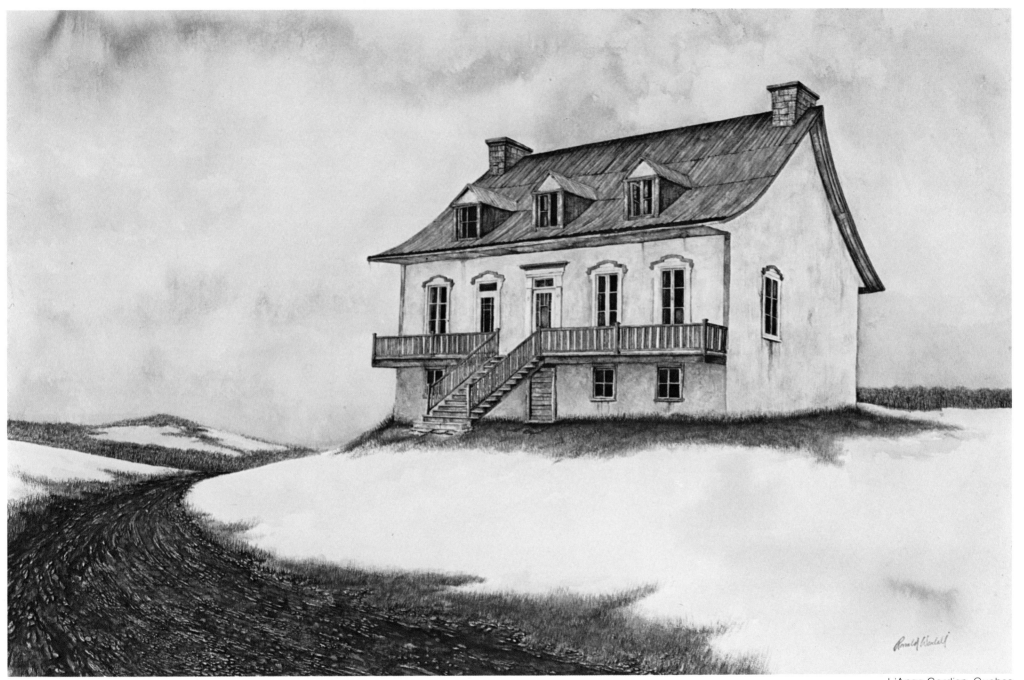

L'Ange-Gardien, Quebec

Ontario must have had some rich farmers. Half of the farmhouses that I found between Toronto and Ottawa would be considered quite posh by western city standards.

The farmhouses of Ontario are by far the most carefully designed and built. They are elegant and ordered. They are also severe and angular, almost humorless, and often foreboding. Waspish perhaps, Protestant certainly. They have been given more time and money and attention to detail than farmers elsewhere could afford. They are embellished with Victorian gingerbread and patterned brick-work. They are the gentry of Canadian domestic architecture.

It took a lot of looking to find the classic Ontario vernacular. Searching the eastern end of the province, I kept rejecting stunning buildings because they were too big or too fancy or too restored or too stripped or too modernized or too eclectic or too hidden by trees. Finally, I found one near Uxbridge that made me say, like Goldilocks, "This one is just right." Still, some aluminum windows and a storm door had to be painted out, a roof replaced, and a balcony fixed. Restoration with watercolor is easy — and cheap, too.

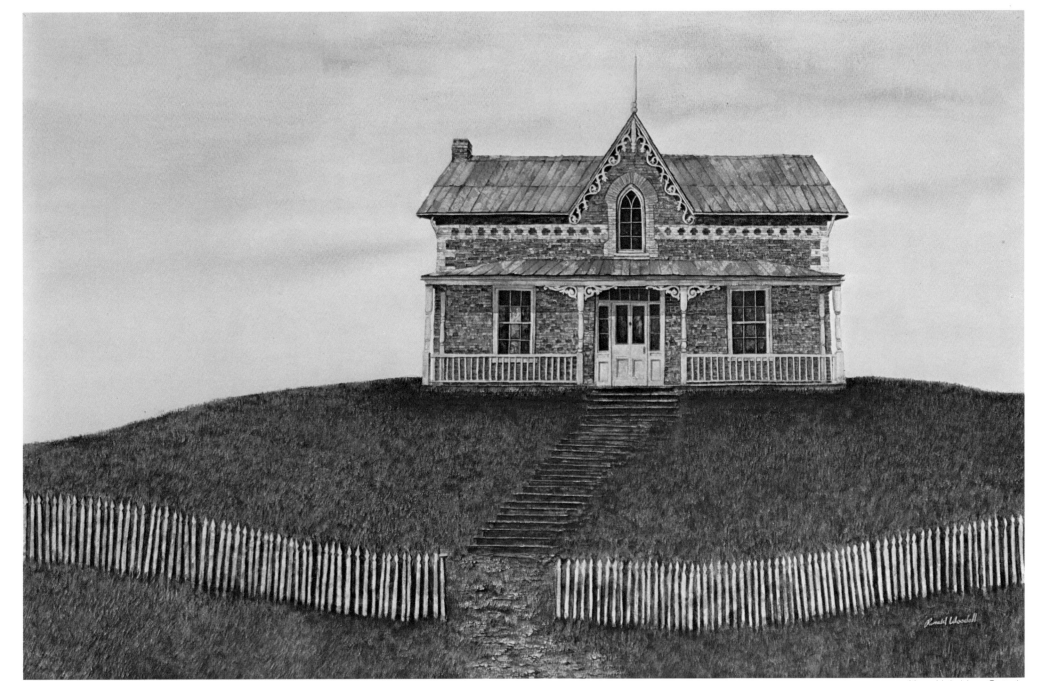

Near Uxbridge, Ontario

Finding a prairie farmhouse for the series was no problem at all. Dozens of examples came to mind. The prairies offer, for me, the perfect combination of terrain, mood, subject matter and exhilaration. Nothing compares with the sensation of standing alone in a wheat field on a warm and windy day. The ground hisses and churns like white water and the earth seems to be alive. Quite often, in late afternoon, the horizon reverses completely when the land becomes the light and the sky becomes the dark. I adore the prairies, perhaps because I go there only in August.

Prairie farmhouses are, more often than not, abandoned ruins. They are dismal victims of drought, depression, agribusiness and urbanization. At their best they were proud and gutsy but poor and doomed. They are strewn across the landscape like skeletal remains. They are small, isolated, empty, lonely and defeated. Their walls are stripped and bleached. Their roofs sag and leak and their windows are black and staring. They are the artifacts of hard times.

For this painting, I chose a little farmhouse that was so alone, it could have been the last building on earth. It was the only structure I remember passing on the forty-mile southerly run we took from Seven Persons, Alberta, to Manyberries, Alberta. Just beyond Manyberries, at Eagle Butte, there is a sign on the road that heads farther south to Wild Horse, Montana. It reads: "No services or residents for 83 miles." That's lonely — but lovely.

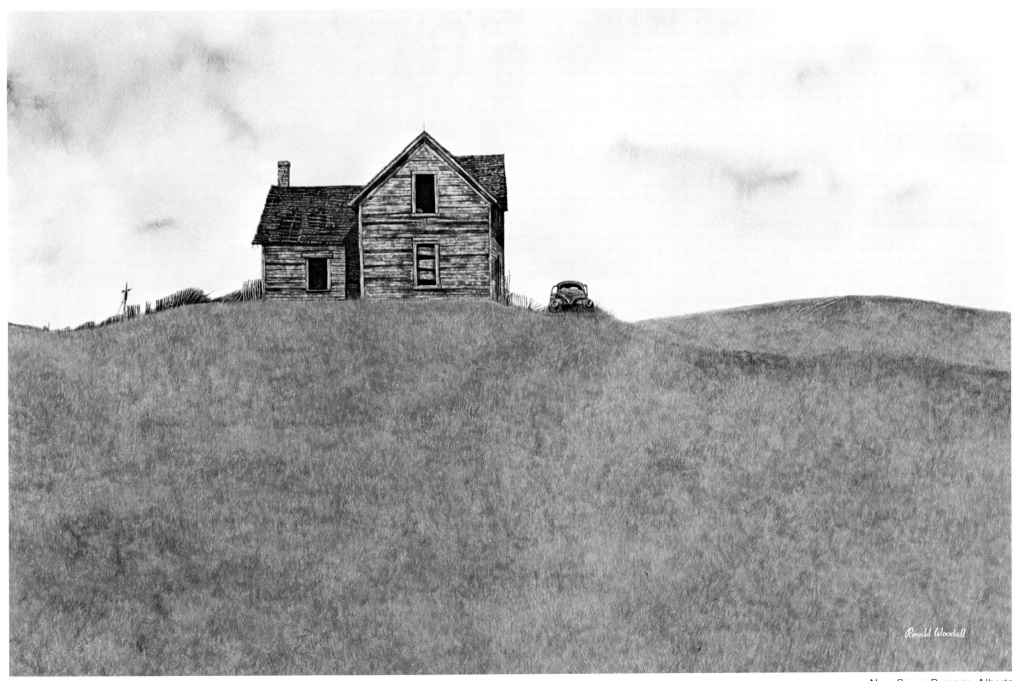

Near Seven Persons, Alberta

British Columbia is almost impossible to categorize. It is so many different places at once. It is Pacific seacoast, island tranquility, lush valley farmland, sagebrush cattle country, rolling prairie, high plateau, rain forest, scrub pine wilderness, mountain grandeur, mining country, wine country, orchard country, and barren northland. British Columbia does not really have indigenous architecture, but it does have a lot of trees. Consequently, it probably has the greatest concentration of log buildings in the country.

The huge axe-hewn homesteads of the interior and the northern frontiers are crude, primitive and organic, but they will stand for-ever. They are basic and tough like the men who built them. They are without frills or niceties. They are little more than massive squares laid out with huge, untrimmed tree trunks, but they are secure and protective and usually snug. And while they have little style or artistry, they are honest buildings and they are one with the land.

This way stop and stable on the old Cariboo wagon road near 70 Mile House has been abandoned for decades, yet it is so structurally sound that a new roof and set of windows could transform it into a home that would last for centuries.

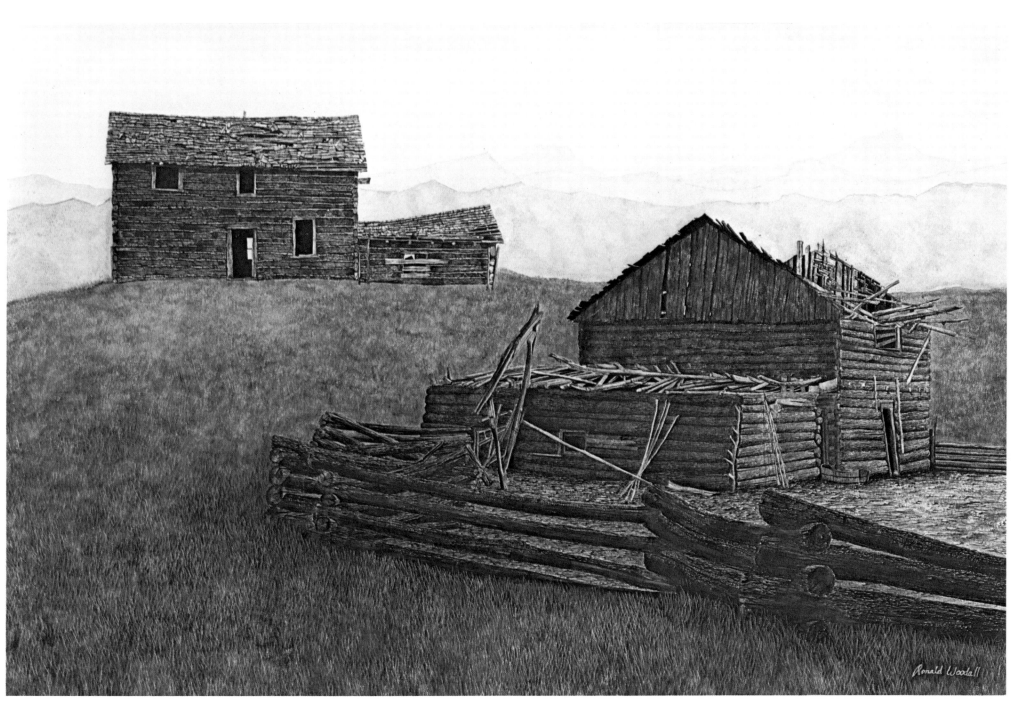

Near 70 Mile House, British Columbia

The wide mouth of the Columbia River is a turbulent and windy place. Whenever I have driven the amazing four-mile bridge that crosses the river to Astoria, Oregon, I have found myself comparing it to the tranquil setting twelve hundred miles upriver at the headwaters.

In the Kootenay country of British Columbia, just about where the Columbia begins to look like a river, there are three little towns poetically named Invermere, Windermere and Athalmer. Invermere is on the west side of the water, Windermere on the east side, and you might say that Athalmer is in the middle. It was built at the point where the lake narrows into the Columbia River and it served as a riverboat stop as early as the 1800s. The community clustered around the swing bridge over the river. River navigation became big business around 1890, when Captain Francis Patrick Armstrong launched a homely steamboat called the "Duchess." As mining boomed in the area, so did steam transport, and soon Captain Armstrong's Upper Columbia Navigation and Tramway Company had a fleet of paddlewheelers and connecting rolling stock. Athalmer, in fact, prospered as a river port until almost 1920, when the Kootenay Central Railway came through and the last steamboat took its final run. Sometime during this heyday, around 1910, a district pioneer named James Lorenzo MacKay built a fine and fanciful office for the Columbia River Lumber Company. Some time later, according to a photo at the historical museum, the building became known as Peakes Hardware. While facts are sketchy and memories hazy, it seems that Frank Richardson bought the place to house his general store and post office. He had it moved to its present site by river barge. But Frank Richardson was also a notary public and decided to build a tiny office at the side so that when he changed hats, he could also change buildings. Presumably in a single stop you could get your will written and pick out your pork chops for supper.

The first time I saw Richardson's buildings, in 1964, I almost drove off the road. At the time, I was fresh from the east and just beginning to acquire an appreciation for old buildings. Even now, after all the years and miles of collecting, I have seen few prettier false fronts. The roof lines had a touch of Western Baroque which is found rarely. Both buildings exhibited that quality which I value above all, an elegance in decay. And they were a matched set!

Recently, on a return trip, I was disappointed to see that the buildings had been separated. They now belong to the local farmers' co-operative. The general store is being used as a warehouse and, until recently, the little notary office was leased to the Chamber of Commerce as a tourist information kiosk up on the highway. The historical society in Invermere would like to have the buildings. The Fort Steele Historic Park would like to have the buildings. But the co-op isn't selling. The situation has all the makings of another needless loss of two superb specimens.

It is easy for a stranger to confuse place names in the Columbia Valley. For one thing, Windermere, Invermere, Athalmer and tiny Wilmer, just up the river, are so close together they practically touch. What is more, they have all had their names changed, so historical references are confusing. This painting was reproduced as a framing print in 1971 and, through carelessness, entitled "Buildings at Windermere." The following year, it appeared in a national magazine. To correct my error, I captioned the picture "These two Invermere, B.C. buildings.." A few people in Athalmer have never let me forget it.

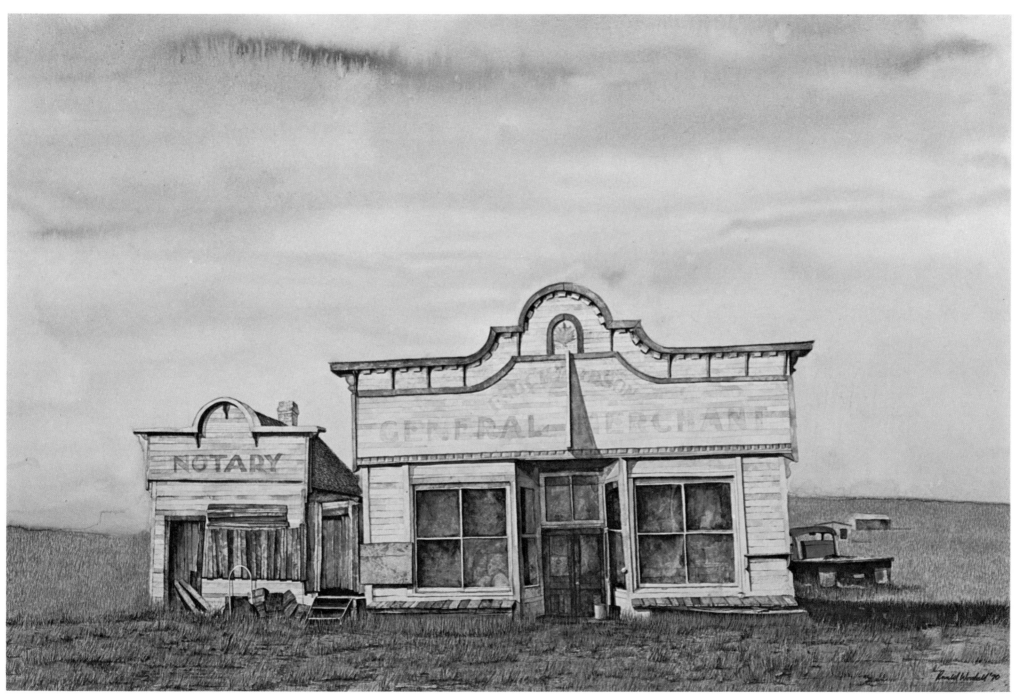

Athalmer, British Columbia

There is no question in my mind as to which area is the richest in vintage western buildings. It is California's Route 49, the Golden Chain Highway between Downieville at the north end and Mariposa at the south. The few times I have been there, I have found the concentration of gold rush architecture overwhelming. Anyone familiar with the history of the California strike and the Forty-niners will find magical names on the signposts of this winding foothill highway: Chinese Camp, Mokelumne Hill, El Dorado, Volcano, Rough and Ready, Coloma, Sierraville, Dutch Flat, Gold Run, Lotus, Shingle Spring, Sutter Creek, Drytown, Amador City, Campo Seco, Hangtown, Jenny Lind, Hornitos, Angel's Camp, Tuttletown, Big Oak Flat, Bear Valley, Vallecito, Murphys, Ione, Jackson, Poker Flat, Copperopolis. These and dozens more are names right out of the pages of Bret Harte and Mark Twain, and preserved here is perhaps the most colorful chapter in the history of the North American West. Because I would like someday to do a series of paintings of the California gold country, I have photographed hundreds of buildings along this route.

This old roadhouse and inn is near Nevada City, a gold rush town still active and populated, which has carried its essential old-west qualities unspoiled into the twentieth century. The only California building in the book, it is included as a token salute to this legendary area.

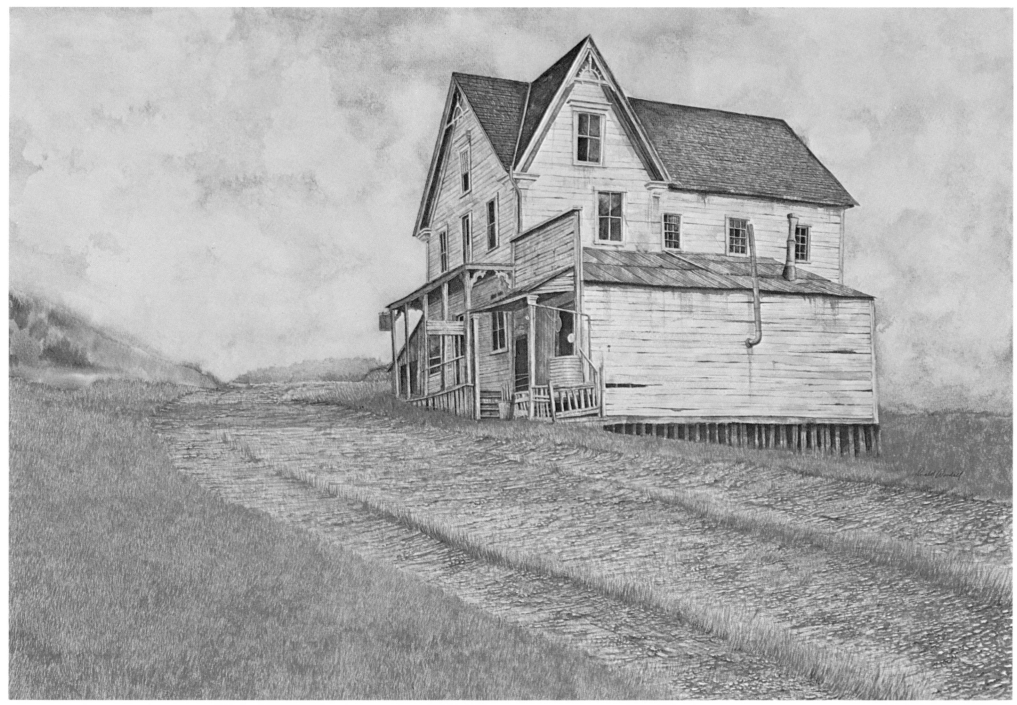

Nevada City, California

Some types of backcountry buildings have almost completely vanished. The old-time hose-towered fire hall is, for example, virtually extinct. Of the few dozen left in the west, this old single-pumper at Moyie is one of my favorites. When I first saw this building, it was weathered and neglected and, to my astonishment, it still had a spindly and dusty hose cart tucked away at the back.

Happily, I suppose, the Moyie Community Association has restored the building since I painted it. They gave it a reddish stain and white trim. They tried to re-install the bell, which had been at Fort Steele for safekeeping, but someone immediately stole it. It surfaced in a Cranbrook dump and now they're trying to weld it in permanently. The wounds and age lines have been removed from the building and the windows have been safely sealed against intruders, and I am so thankful to have seen it in its tattered glory.

The Moyie fire fighters were volunteers and the cry of fire brought all hands running to the pumps. Their pay was excitement and pride: saving lives was quite simply a citizen's duty. They wore scratchy red shirts and leather helmets with ornately tooled fronts. They used leather hoses and leather buckets and decorative hand pumped engines with names like "Coffee Mills" and "Piano Boxes." Early fire brigades were also men's sporting clubs. They sustained their spirit beyond the occasional fire fighting with competitions in hose laying and pumping and a truly spectacular event called the Hose Reel Race. Teams of six to fourteen men pulled heavy hose tenders in main street races. Such an event was held in Moyie every First of July and the home team, it is said, was the best in the East Kootenays.

Moyie is about half way between Cranbrook and Yahk, in case you were wondering. Today, Moyie is a pleasant little community of white cottages on a clear lake and it is a relaxing stop for highway travelers. But when the fire hall was built at the turn of the century, the town was quite different. There is an interesting story here. In 1887, Father Nicholas Coccola O.M.I. of the St. Eugene Mission on Moyie Lake needed funds so he decided to go prospecting. He showed a sample of ore to the Indians and asked them to watch for more. In 1893, an Indian named "Peter" found a huge chunk of galena and brought it to Father Coccola and a prospector named James Cronin, who happened to be at the mission that day. Peter then led the two men to the biggest raw ore outcropping they had ever seen. A land rush followed, a 300-ton concentrator was built, and Moyie became the biggest silver-lead operation in Canada. By 1911, the riches were gone. Father Coccola netted enough to build his white church, which still stands. Peter got $300 and a house. Cronin left with half a million, which says something about being at the right place at the right time.

Today, Moyie has no fire department. I asked a local what they would do in an emergency. He said they would pray.

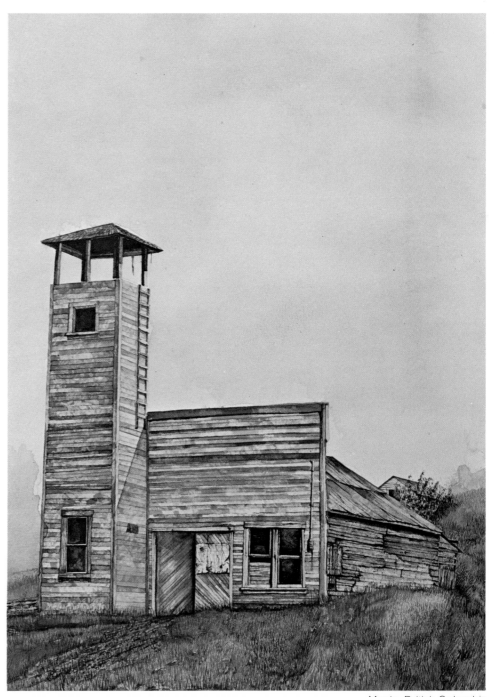

Moyie, British Columbia

God must love little churches because he has left so many of them standing. Churches are different from other old buildings. No one ever thinks of them as old-fashioned. I suppose that is the religious tradition at work. Usually, the vandals and wreckers are kinder to churches. They are the last buildings to have their doors torn off, their windows broken, and graduation years spray painted on their walls. Often, they are left alone, sometimes with pews and hymn books and altars intact and in place. It is quite miraculous. Of the thousands and thousands of old buildings I have collected, churches make up the biggest single category. Some of them have become scout halls or libraries or basketball courts, but still they stand long after the town has leveled its history for the sake of progress. Even bureaucratic Philistines are afraid to bring down the church.

This is one I had to paint. It does not have any history to speak of, but it is so dramatic. It sits there like a huge spike driven point up into the prairie just west of Saskatoon, Saskatchewan. So severe. So stoic. You can't miss it.

St. Andrew's Presbyterian was built in 1903 and dedicated on July 24 of that year. The labor was volunteered and the two acres were donated. The materials cost $1,648.97. Local belief has it that the name St. Andrew's was chosen because the first minister was Reverend Andrew Little. A lovely gesture if true, but one that few old Presbyterians would believe. St. Andrew's was probably the first Presbyterian church on the Winnipeg-to-Edmonton main line.

The records of old churches are charming. In 1905: ten subscriptions of the "Standard Choir Monthly" are ordered from New York; 1907: the minister's salary is $625 plus $275 from the Augmentation Fund; 1909: the Ladies Social Club is formed; 1910: pledges amounting to $1,000 are made for the manse and four months of collection plates yield $81.66; 1914: the Women's Missionary Society is formed; 1915: the Cheerful Fund is started to help the church and a mission band is organized; 1917: the basement is completed; 1918: a hymn board, collection plate, and set of communion cups are purchased; 1920: a rack for the communion cups is purchased. In Saskatchewan, folks usually married and buried out of their homes. The church recorded only ten weddings and three funerals in sixty years.

St. Andrew's, startling in its isolation against the horizon, has long been a landmark west of Saskatoon, but the city crawled out slowly into the farmlands, and shortly after its sixtieth anniversary celebration, the building was abandoned. The congregation moved to Trinity Church in Saskatoon.

Up the road a bit, there is a church cemetery. In potter's field at the northeast corner, a man named Aroomiah is buried. He was with the Nestorians, a group of converted Persians who were trying to reach the Barr Colony at Lloydminster. He died en route, just as St. Andrew's was being completed. So they buried him there. According to the Saskatoon *Phoenix*, thirty-five Nestorians came to Saskatchewan in 1903. Another five thousand were expected. They never came.

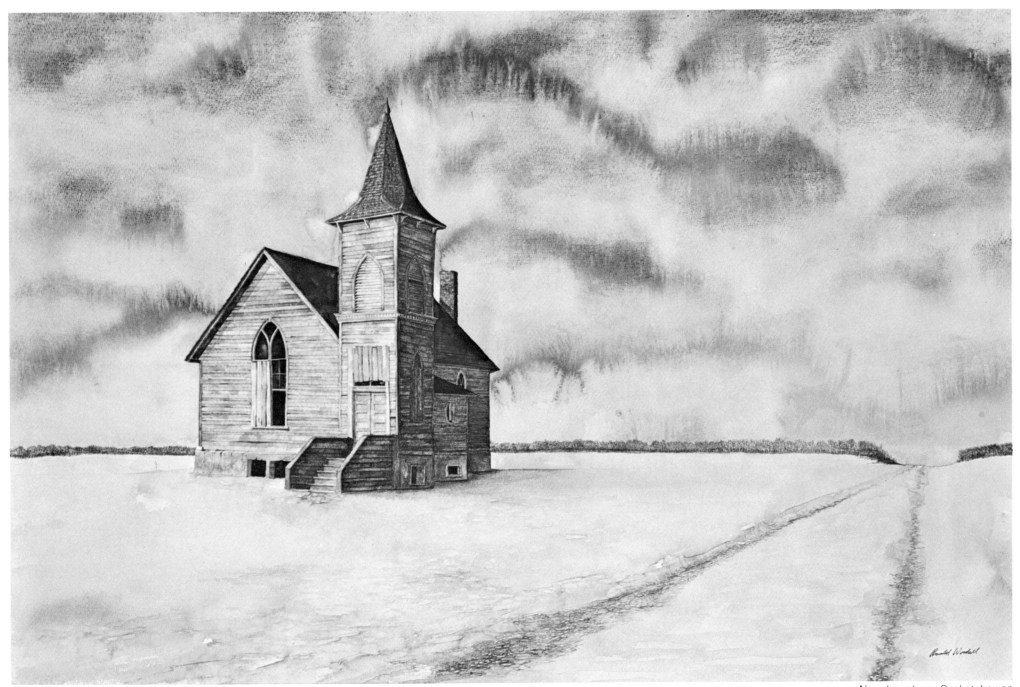

Near Langham, Saskatchewan

Here is a little exercise in variation. The building is only a log feedshed on Pavilion Mountain. It stands alone in the middle of grazing land at the edge of the Fraser Canyon, about fifteen miles north of Lillooet, British Columbia. Perhaps I should have said stood, because when we drove the very rough switchback road over Pavilion Mountain last year, I could not find the feed shed. It stood out so clearly in its isolation that I am sure it is gone.

The simple and pleasing geometry of the building seemed to me so perfect that I painted it many times, making changes only in the terrain, the seasons, and the ground cover. Here are four of those paintings.

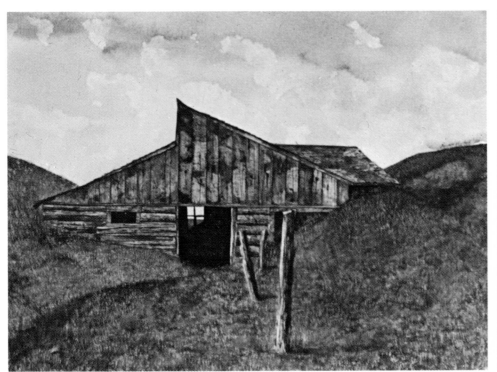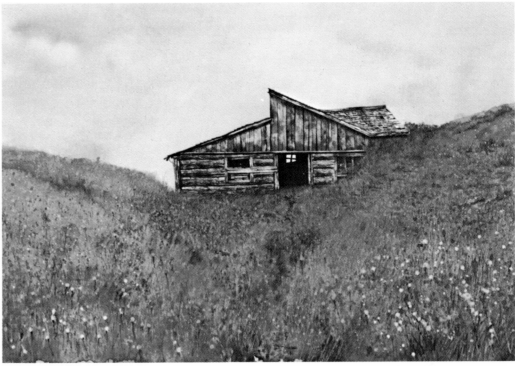
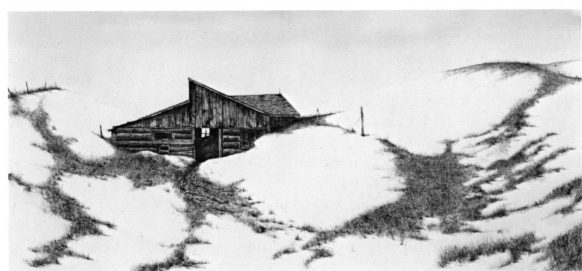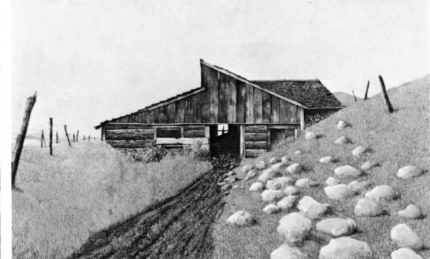

Pavilion, British Columbia

The side roads looked inviting as we headed west from Missoula, Montana, somewhere near the town of Superior, so we turned south and snaked into the rolling hills. Soon, we spotted a proud and snowbent log barn that was handsomely textured and weathered. We doubled back and as I was preparing my camera equipment, a dog barked and a gaunt, sinewy woman in work clothes came out of the farmhouse to see what we wanted. At first, she looked unfriendly. I told her we were admiring her barn. She beamed. "You love that old barn, too? C'mon inside then. Thought you were hunters. Think they've shot one of my dogs. Hasn't come back for a couple of days. They'll shoot anything that moves during hunting season." We assured her that we shared her dislike of the sporting set.

Pat Oscar is sixty years old and lives alone on 329 acres of barren ranchland, a mile from her closest neighbor. She does not own a car. Since our meeting, we have exchanged some letters and hers are filled with the realities of a lone woman scraping a meager living from a harsh land. Judging from the things I have learned about her, she is very, very tough.

How tough? As an arthritic-rheumatic child, she was given three weeks to live. As an adult, she was given three minutes to live when she refused a transfusion because of her scriptural beliefs. At the age of nineteen, in Massachusetts, she was tough enough to be the lone night nurse for 134 semi-violent patients in a mental hospital. In Colorado, she ran a sawmill, and fulfilled a girlhood dream by single-handedly building a log cabin in the mountains. She used mining ties cut at her own mill and nailed them together with eleven inch spikes that she drove home with a two-and-a-half pound sledge-hammer. At the mill, she carried and stacked 5"x5"x10' ties for seven hours a day and once loaded 1,770 pine planks on a truck in less than five hours. She weighed 118 pounds.

Now, she lives in a quaint little farmhouse with her dogs and cats. After chores, she reads the scriptures, does pastels of animals, makes exquisite embroidered quilts, and educates herself constantly. In a way, her entire home is a patchwork quilt. She loves patterns. Every wall and ceiling is papered in its own design. The floors are linoleum floral gardens. The furnishings and the 1881 wood stove are baroque. There are tapestries on the walls and yo-yo quilts on the canopied four poster. And everywhere, a treasure trove of memorabilia.

Out at the barn, we were sitting our children on the pony and Pat was talking about a man named Buckley who built the structure in 1905, when quite casually she mentioned the still. "Best corn likker in all of Montana, they said!" We were dumbfounded. We have been in a thousand barns but had never seen one with a trap-door leading to a damp, dark basement still. I went down the rotting stairway and could make out a few bottles on the shelves, but the equipment was gone. Recently, I wrote Pat for details. "Silence," she wrote back. "No buddy tellin nuthin no way. Montanans are funny about things like that. Tell nuthin to no buddy." So that's that.

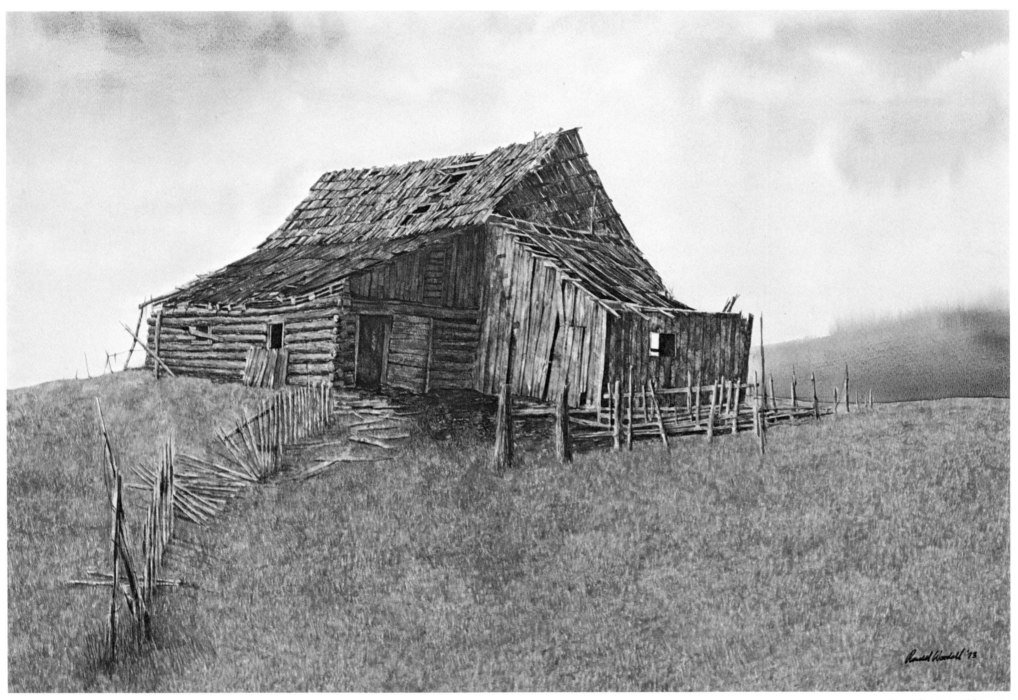

Near Superior, Montana

This painting exposes me as an artistic and historical charlatan. But it is also a good example of one of the advantages that painting has over photography.

Virginia City, in southwest Montana, while often dismissed in ghost town guidebooks as a tourist reconstruction, is one of the most authentically preserved and restored mining camps you will find anywhere. It still has a few hundred original structures including an opera house, a brewery, several saloons, a blacksmith shop, the oldest newspaper office in Montana, a stately courthouse, and buildings claiming shoot-outs and vigilante lynching parties.

Despite all of these, my favorite has always been an aging little house a block up the hill from the main street. It has refined proportions, just a little taller and slimmer than most homes of the period. At the rear of the structure, a long country kitchen connects to a charming cluster of outbuildings.

In 1870, a miner named Jacob Simpson constructed a one-room hand-hewn squared log cabin with a small lean-to. Three years later, he sold the property to a family named Cole, who, finding the cabin too small, built the house out front. The Coles lived there for fifty-seven years, and there is evidence in the numerous structural changes that additions were tacked on as the needs arose. Until quite recently, the bathroom was located in the original cabin and the pantry in the lean-to. These buildings are included in the con-

nected complex at the rear. The property changed hands in 1937 and again in 1947. It now belongs to a lady named Evalyn Johnson. She refers lovingly to the house as her "Gingerbread Castle." Another nickname she uses is "Rottonwood Manor," suggesting a pressing need for some restoration. Unfortunately, Mrs. Johnson lives 3,000 miles away in the state of Virginia and the house has been empty for fourteen years.

Here, I must confess a few things. The house is situated at the intersection of Idaho and Hamilton Streets, behind the courthouse. It is in a residential area of closely spaced old homes. The streets are paved and they have sidewalks and telephone poles. When painting the building, it occurred to me that if the artificial brick siding was removed to expose the original frame construction, and if the shake roof was aged a little, and if the entire structure was moved to the crest of a long sweeping hill, it would look stunning. So that's how I painted it. Perhaps I should not do this, but it certainly is fun.

Once, we went into the office of the *Madisonian*, Virginia City's 1873 newspaper. Having heard that several scenes from the film "Little Big Man" had been shot on the main street, I innocently asked the editor what parts of the town were real and what was movie set. He seemed terribly upset. "Why do people keep asking that? It's all real. We don't change anything around here." I hope he never gets to see what I've done with the house at the corner of Idaho and Hamilton.

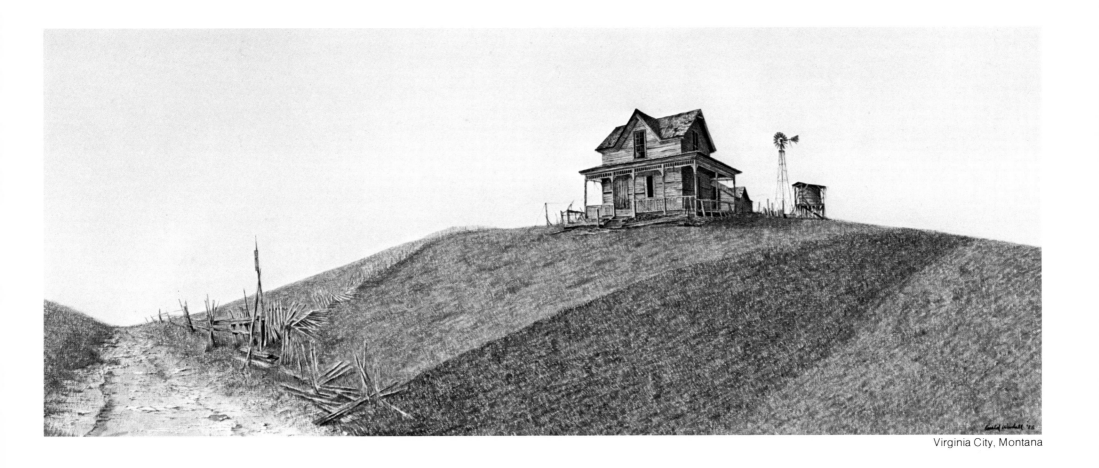

Virginia City, Montana

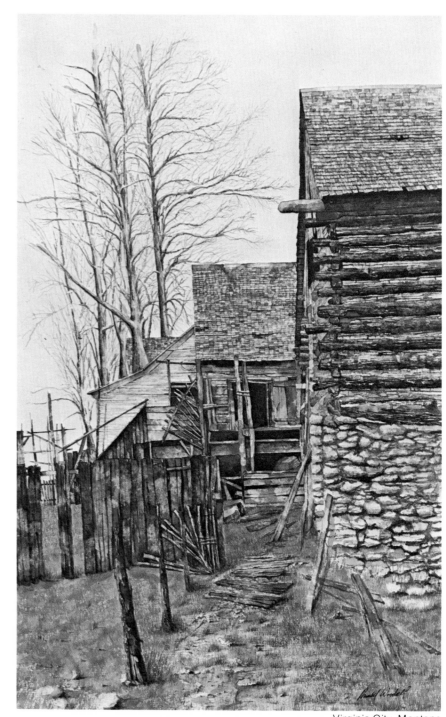

Virginia City, Montana

Here are a few more buildings in Virginia City, Montana. For anyone who appreciates gold rush architecture, a wander through this town is utterly mind-boggling. On both my visits, I was too pre-occupied with the experience to take notes and so am indebted to historian Dick Pace for the following information.

The building at top right is the Henry S. Gilbert Brewery which was built in 1884 to replace the 1864 structure, gutted by fire. The Gilbert family ran the brewery continuously until prohibition forced them to close in 1920. A subsequent attempt to manufacture soft drinks was unsuccessful. Beside the brewery building is an old hip-roofed stone bottling plant. In Dick Pace's book *Golden Gulch*, there is an old tintype of both buildings and they are, to this day, unchanged.

The lower painting is of Karl Sauerbier's blacksmith shop, which operated from the 1870s until the 1920s. The great thing about blacksmith shops is that they are so black, and peering through the soot-covered windows proved this one to be no exception. I seem to recall, also, a dusty collection of horse-drawn vehicles in the adjoining buggy shed.

On the opposite page is a study of some back yards, along Alder Gulch behind the town, a delightful maze of aging debris. Often, the rear views of old towns are the most interesting. Nobody tries to modernize back walls, so if you really want to see the age lines and wrinkles, try walking the alleyways. They are usually original.

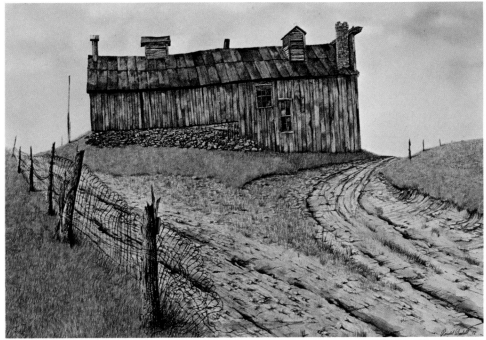

Virginia City, Montana

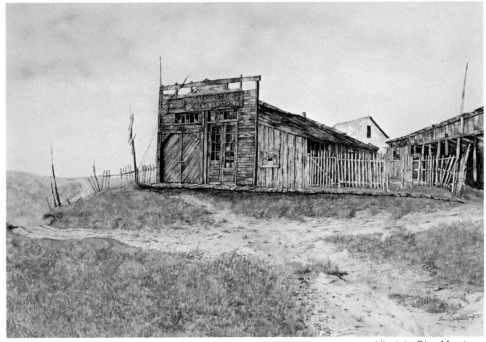

Virginia City, Montana

Quick, British Columbia, is the kind of place you discover by accident. It is just off the Yellowhead highway, near Telkwa. A little sign beckons the curious, and those who make the turn are treated to a two-mile meander over pastoral benchland and down into the valley of the Bulkley River where, beyond an ancient bridge, they see the massive, rambling building that is all that remains of Quick.

Seeking a little information on this strange structure that seemed to be a long series of mismatched additions, we approached a young man working on a battered pickup truck. He suggested that we talk to Mr. W. L. Paddon, the perpetuator of Quick.

Wadham Paddon is eighty-six years old. Like so many country old-timers, he is trim and healthy. He has a lean, tanned face, a full head of hair, alert gray eyes, and a keen mind. Here is his story. His family farmed in the Okanagan, went to war, worked on the railway and on a survey crew, was a forest ranger, and finally, in 1921, he settled down. The Canadian National Railway had just bought the bankrupt Grand Trunk Railway, and Quick seemed the perfect place to build a general store. At that time, the railway was the only land route to Prince Rupert. The road ended seventy-five miles to the east and boat travel ended sixty miles to the west. The road to the coast would have to wait for World War II and the U.S. Army Engineers.

Though he had never built anything before, Paddon singlehandedly constructed the first Quick store in 1922. Soon afterward, he hired a handyman named Long Sing, who, he assured me, was the best carpenter-gardener-blacksmith-horseshoer in the valley. Together, they began to add to the original store, and the great structure grew haphazardly in all directions. (Some years later, Long Sing returned to China and was murdered for the money he was assumed to have.) Soon, Paddon had a staff of five. Food, drygoods and hardware were sold from the main store; feed, tack and farming supplies from the big end-shed. The building served as a post office and, at times, a boardinghouse and hotel. It was a busy and active trading center and prospered for two booming decades.

Then, in the 1940s, fewer and fewer trains stopped there, until, by 1960, Quick was bypassed forever. The highway competition had finally made this rail stop uneconomical and, like so many of the other tiny settlements spaced every eight miles along the tracks, Quick became a railway ghost town. About ten years ago, the stations were systematically torn down, burned, and plowed under. No one wanted to pay the taxes. The big depot and the section foreman's house at Quick came down with the rest, and all that remained was Paddon's general store.

Today, the shelves are sparsely stocked with only one or two of each item. Everywhere, there are little boxes of secondhand debris for sale. The feed shed is a depository of old saddles, trapping gear, flour sacks and farm tools. The barrel wood stove and the ornate green scale are still in use, and the twenty-four hour Regulator clock is still ticking.

But the two dozen glass post office boxes are empty except for dust, and out on Paddon Avenue, it is very, very quiet.

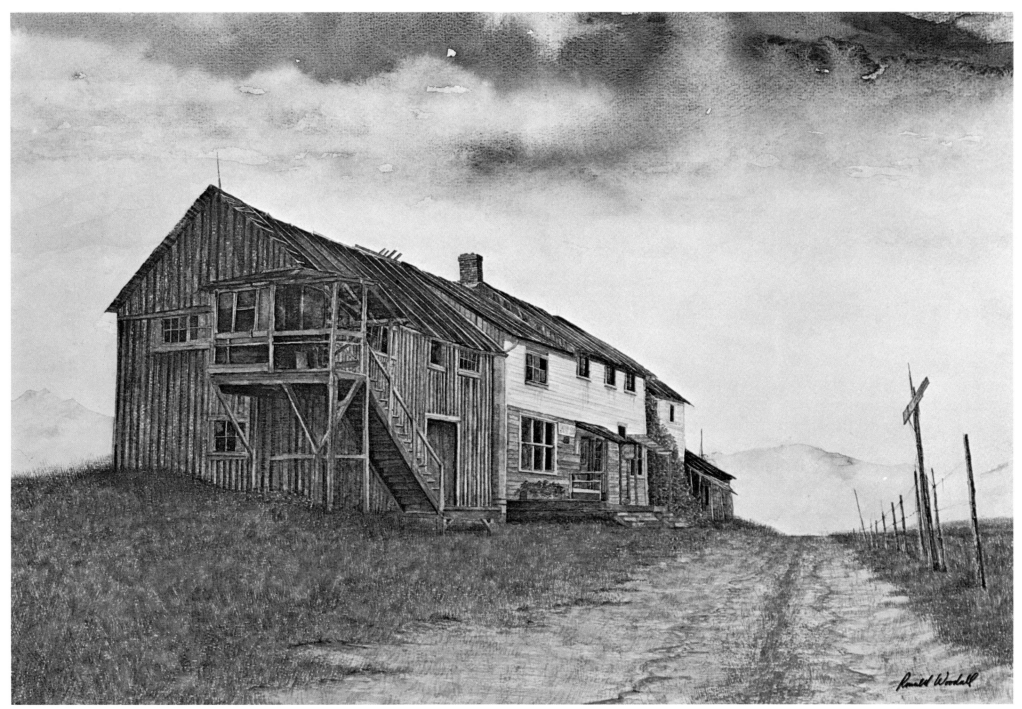

Quick, British Columbia

Cariboo barns are a distinct breed of building, quite different from the trim Dutch gambrels you see in those pastoral scenes on calendar art. Cariboo barns are massive, axe-hewn fortresses built by men who were racing the onset of winter. There was little time for niceties, and delicate cupolas were forsaken for the solid dovetailing of enormous fir timbers. The barns of the Cariboo were built to outlive the builders and the grandchildren of the builders. To this day, it is these barns, more than anything else, which retain the romance of the Cariboo's pioneer beginnings.

This classic example is at Kersley, seventeen miles south of Quesnel. For a mile or two around Kersley, the old road wanders back and forth across the straightened highway. The barn stands just north of French Road, a cutoff built in 1906 to haul the gold dredge to the Quesnel River. Typically, it is well ventilated with the hayloft open front and back. The original shake roof is a colorful mosaic of splintered cedar, corrugated tin, patches made of flattened rusty oil cans and the blackness of gaping holes. The door and handmade hardware are exquisitely aged. A tall loft ladder angles across the front wall. A rusted horseshoe is tacked to the door frame.

The barn was built in the late 1800s by an "axeman" named Blackwater Johnnie for a Scot named Harrison who had driven freight teams from Ashcroft to the Cariboo. Originally built with horse stalls, the barn was used by Harrison to stable the teams stopping at nearby Kersley House. In 1905, with the help of a Yorkshireman named Jack Barlow, Harrison built a fine residence across the road

from the barn. Here he provided straw mattress lodging for the overflow travelers from Kersley. The fanciful filigree of trim added by Barlow can still be seen on the house. Harrison married an Indian princess called "Betsy." A large Indian band camped at the farm then, but shortly after Harrison's death, the local ranchers formed a vigilante group and ran them off. Betsy then decided to sell the property to Barlow's brother Bob. The price, $2,000 for thirty cleared acres, was high for 1910. The Barlows added a Crown grant and raised beef, chickens and pigs. Barlow went to war in 1914, leaving a half-finished second barn to be completed in 1918, and the rotted lower timbers attest to the unprotected years. In 1940, the farm was bought by the F. W. Edwards family who provided the historical data. They ran a dairy herd until 1962, when they turned to ranching with Aberdeen Angus cattle. They built a new barn during the fifties and since then have used the old one for hay storage and the wintering of the milk cow, the calving cows and the orphans. The spread has now grown to 800 acres.

Throughout the occupancies, a story has persisted about a lost gold mine on Dragon Mountain near the farm. It was discovered by a mysterious friend of Harrison's known only as "Deschamps." Deschamps was killed by the kick of a mule and apparently took his secret to the grave.

This painting, dated 1967, was my first watercolor, first building painting, and, though I hardly knew it at the time, the beginning of this book.

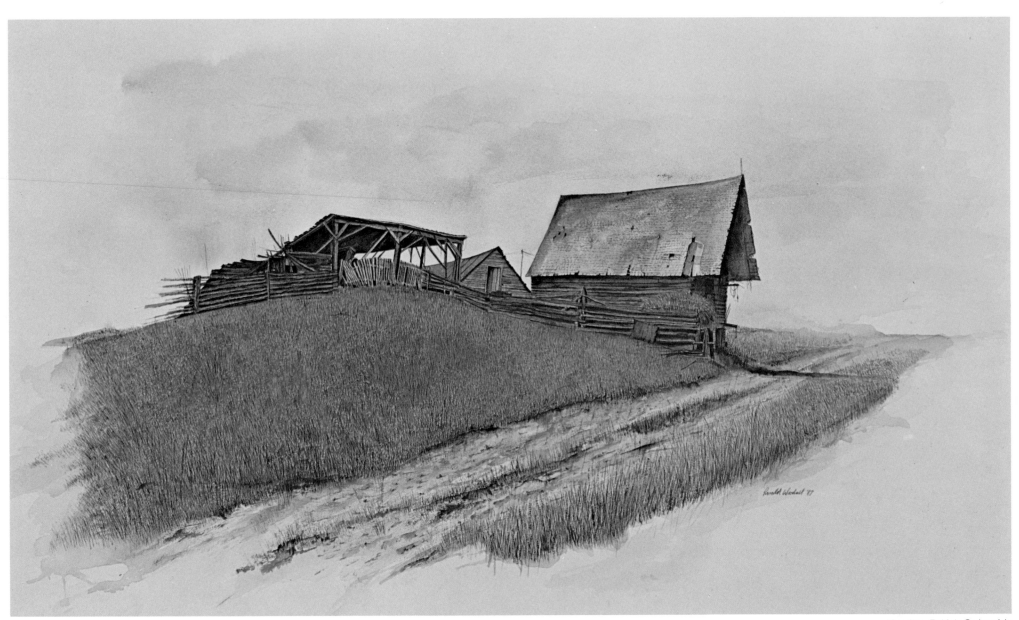

Kersley, British Columbia

St. Saviour's Anglican Church is the Eiffel Tower of the Cariboo. You will find it on every second tourist brochure produced in British Columbia. Its fame is easily understood, for it stares straight down the main street of Barkerville, one of the most authentic gold town restorations in the world. (Again, for purely artistic reasons, I have isolated St. Saviour's in the painting.)

St. Saviour's is the only surviving church in Barkerville, which was never a particularly religious place, considering the fact that a sparse sprinkling of churches competed for souls against a few dozen saloons and as many whorehouses.

The great fire of 1868 left Barkerville without an Anglican church, so a Yorkshireman, Reverend James Reynard, set about to design and build another. It was an unhappy ordeal, plagued by horrible winters, a lack of money, and total indifference from the towns-people. Things cost too much. To get windows from Victoria, the Reverend had to pay five dollars in transportation charges for every dollar of glass. Reynard and his family lived on near-starvation rations while he poured his small stipend into construction costs. They "treated" themselves to potatoes on Sundays and cabbage at Christmas. The Reverend died a few years later from "overwork, disappointment, and privation."

But what a lovely church he built! It is like a tiny Gothic cathedral with a great vaulted arch above the chancel and sanctuary, and slender arched windows running across the face, along the nave, and behind the simple altar. Reynard's original hand-crafted pews stand as solidly as the day he built them. The square nails have held the original exterior timbers through more than a hundred Cariboo winters, and the roof has withstood a century of six-foot snowfalls. The electrically wired hobnail hanging lamps are a recent but fitting addition. Halfway down the nave, looking much like a baby hippopotamus, is a fat, black 1867 "Mogul" wood stove. St. Saviour's still functions as a church and not, like the rest of Barkerville, as a museum. Regular services are held and the sign tacked out front reads "Weddings and Baptisms by appointment, Most Reverend R. S. Dean, Archbishop of the Cariboo."

Here is a story, heard third hand, about Archbishop Dean who, I am told, is a wiry Cockney who worked his way through theological school by playing professional soccer. It seems an interesting comment on an English clergyman's adjustment to the wild west. One day, on a large ranch somewhere in the Cariboo, he was sitting atop a corral fence witnessing, for the first time, a branding and castration operation. The ranch foreman asked what he thought of the spectacle. The Archbishop replied, "I prefer baptism."

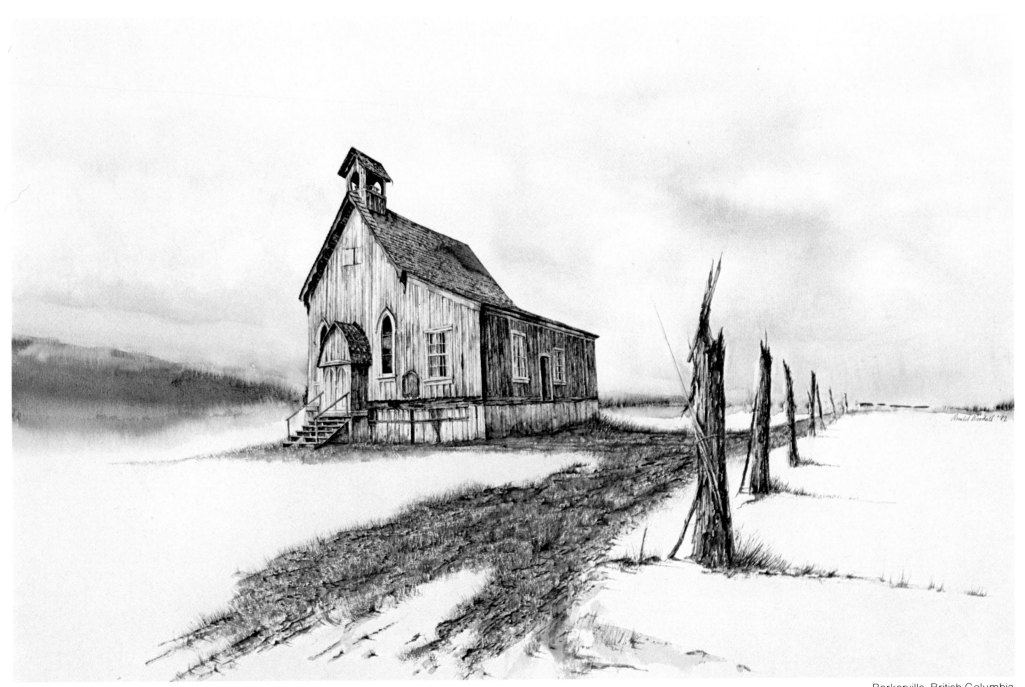

Barkerville, British Columbia

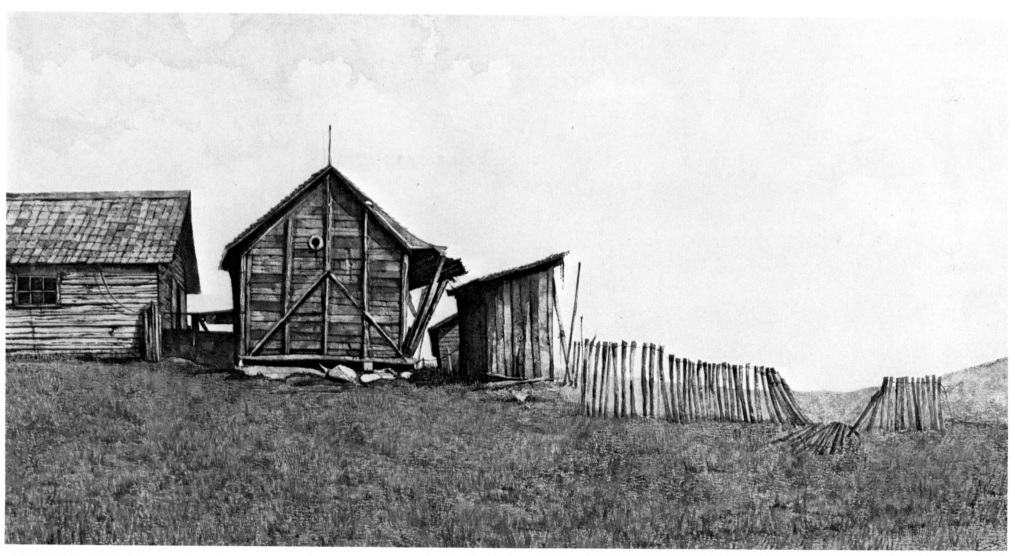

Monte Creek, British Columbia

Even the plainest of buildings can have aesthetically pleasing qualities. Here are three humble structures that seemed to deserve a second look.

At left is a tableau of shacks near Monte Creek, British Columbia — a tool shed, a chicken coop, an outhouse, and some collapsed snow fencing.

At top right is a fish boat shelter in the native village of Cape Mudge, at the south end of Quadra Island in British Columbia's Strait of Georgia. These shelters have been built in a string along the beach in front of the settlement. When empty, they take on a bizarre look.

At bottom right is a miner's shanty at Nighthawk, Washington, an abandoned mining town several miles south of the Canadian border. Nighthawk was the northernmost of the communities that sprang up along the banks of the Similkameen River in the mining boom of the early 1890s. Today, this cabin stands alone, staring across the river at the mill ruins of the old Ruby Silver Mine.

Perhaps these structures appear to be little more than firewood, but I find them quite beautiful, and so decided that the meek shall inherit the end of the book.

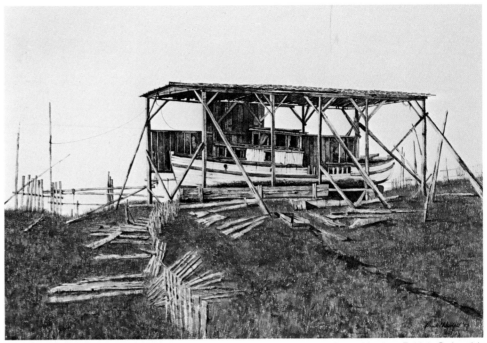

Cape Mudge, British Columbia

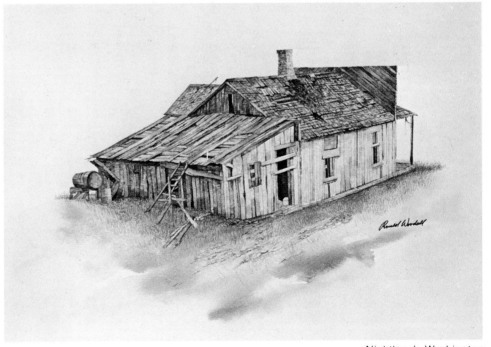

Nighthawk, Washington

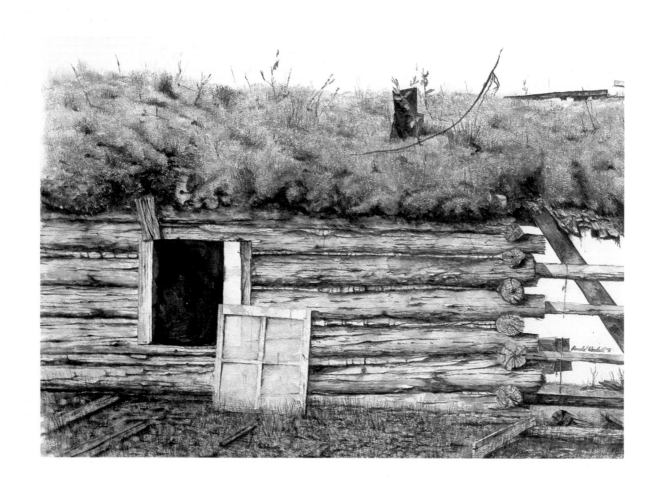

Opposite: A sod-roofed hired hand's cabin on a small ranch near the U.S. border south of Keremeos, British Columbia.

The Canada Council provides the means to buy that precious time needed to bring a project like this together. Without their help, I could not have finished this book.

Acknowledgements

A lot of nice people helped me with this book and I owe each one of them my thanks.

First of all, bless you, Canada Council.

Next, I would like to express my indebtedness to three distinguished gentlemen: Dr. Eric Arthur, professor emeritus of architecture at the University of Toronto, author of *The Barn*, and one of the most charming people I have ever met; Willard E. Ireland, who before his retirement was provincial archivist and librarian for British Columbia, and Robert A. J. Phillips, executive director of Heritage Canada. These men gave me their support when this book was nothing more than an idea.

A great many friends, old and new, have contributed in one way or another. Some of them gave my work the early exposure which eased my way into this book. Some welcomed me onto their farms with a lovely story and a glass of homemade wine. Some lived with an empty wall when I borrowed back a painting for photocopying. Some responded to my desperate, deadline-pushed letters of inquiry with a generous outlay of time and effort. The people named below each know exactly how they helped this book toward completion. To each of them, my thanks.

Mrs. H. Aikenhead, Duncan, B.C.
Mr. & Mrs. R. Baird, New Westminster, B.C.
Mr. & Mrs. I. Bell-Irving, Vancouver, B.C.
Mr. Leon Bibb, Vancouver, B.C.
Mr. Trevor Braithwaite, Montreal, Que.
Ms. Mary Caple, West Vancouver, B.C.
Ms. Avis L. Choate, Clinton, B.C.
Mr. Ed Chow, Duncan, B.C.
Mr. Chung Chuck, Ladner, B.C.
Mr. Eric C. Collier, Carmangay, Alta.
Mr. Ron D'Altroy, Vancouver, B.C.
Mr. Art Dawe, Duncan, B.C.
Ms. Dorothea Dean, Wilmer, B.C.
Carlos and Marilyn Diligenti,
 West Vancouver, B.C.
Ms. Colleen Dimson, Toronto, Ont.

Mr. & Mrs. F. W. Edwards, Kersley, B.C.
Mr. Bill Ellis, Vancouver, B.C.
Mr. Philip Eprile, Toronto, Ont.
Mr. Enn Erisalu, Vancouver, B.C.
Mr. & Mrs. W. Esson, West Vancouver, B.C.
Mr. George Farr, Toronto, Ont.
Cam and Fran Ferguson, Toronto, Ont.
Dr. & Mrs. A. C. Gardner Frost, Vancouver, B.C.
Dr. & Mrs. Tom Godwin, Surrey, B.C.
Mrs. K. Graves, Vancouver, B.C.
Mr. Jim Harris, Medicine Hat, Alta.
Mrs. O. J. Harris, Shoshone, Idaho
Mr. David Henderson, Vancouver, B.C.
Mr. A. Hokanson, Norris, Mont.
Mr. & Mrs. C. Holder, Calgary, Alta.
Ms. Marlene Hore, Montreal, Que.
Ms. Vera Hueston, Brock, Sask.
Mr. Lee A. Iacocca, Dearborn, Mich.
Ms. Evalyn B. Johnson, Fairfax, Va.
Mr. Acton Kilby, Harrison Mills, B.C.
Dr. & Mrs. P. King, Burnaby, B.C.
Mr. John Koralewitcz, Invermere, B.C.
Mr. Hal Kreiger, Vancouver, B.C.
Mr. & Mrs. John Leonard, North Vancouver, B.C.
Mr. Ray Little, Vancouver, B.C.
Mr. Blair Macdonald, West Vancouver, B.C.
Mr. Dan MacDonald, Moyie, B.C.
Mrs. Mildred MacDonald, Squamish, B.C.
Mr. Bill Mayrs, Vancouver, B.C.
Mr. Terry McDougall, Ottawa, Ont.
Mrs. Kathryn McGreer, Antelope, Ore.
Mr. & Mrs. Robert MacKay, Edmonton, Alta.
Dr. & Mrs. J. R. Miller, Burnaby, B.C.
Ms. Mary Moon, Vancouver, B.C.
Bill and Janice Moore, Winter Harbour, B.C.
Mr. E.A. Morrison, Vancouver, B.C.
Ms. M. L. "Ma" Murray, Lillooet, B.C.
Mr. Max Newton, Montreal, Que.
Mr. & Mrs. G. O'Leary, West Vancouver, B.C.
Mr. & Mrs. Garth Olmstead,
 North Vancouver, B.C.
Mr. Stanley Olsen
Ms. Pat Oscar, Superior, Mont.
Mr. Dick Pace, Helena, Mont.
Mr. W. L. Paddon, Quick, B.C.
Mr. E. Parsons, Saltspring Island, B.C.
Mrs. Peggy Patenaude, 153 Mile House, B.C.
Ray and Heidi Peters, West Vancouver, B.C.
Dr. Barry Purcell, Vancouver, B.C.
Ms. Gayle Purcell, Vancouver, B.C.
Mr. Jim Quaife, Duncan, B.C.
Mr. R. Quirole, Quick, B.C.
Mr. Denis Robert, Montreal, Que.

Mr. & Mrs. Donald C. Robertson, Toronto, Ont.
Mr. Vic Scott, Clinton, B.C.
Mr. John Sebert, Toronto, Ont.
Mr. George Sheppard, Saskatoon, Sask.
Mr. & Mrs. N. Stade, Rosedale, B.C.
Mr. & Mrs. R. T. Stewart, Manila, Philippines
Mr. Randy Streit, Duncan, B.C.
Mrs. G. Tatlow, Cranbrook, B.C.
Ms. Hilda W. Taylor, Saskatoon, Sask.
Mr. Darryl Tichenor, Virginia City, Mont.
Mr. & Mrs. John Tierney, North Vancouver, B.C.
Ms. Winnifred Weir, Invermere, B.C.
Mrs. Inez Wilde, West Vancouver, B.C.
Mr. Johnnie William, Harrison Mills, B.C.
Doug and Tannis Williams, Vancouver, B.C.
Mr. Thomas Wood, Irvine, Alta.
Mr. & Mrs. W. E. Woodall, Victoria, B.C.
Mr. & Mrs. W. E. Woodall, Victoria, B.C.
Mr. S. S. Woodside, Vancouver, B.C.
Mr. & Mrs. N. Woolliams, Douglas Lake, B.C.
Mr. Richard Wright, Port Moody, B.C.

Building Products of Canada, Ltd.,
 Montreal, Que.
Davis & Company, Vancouver, B.C.
Equinox Gallery, Vancouver, B.C.
Ford Motor Company, Dearborn, Mich.
Holiday Inn Harbour Side, Vancouver, B.C.
Scott Paper, Ltd., New Westminster, B.C.
J. Walter Thompson Co. Ltd.
Weekend Magazine
Westworld Magazine

Franz Lindner, a Vancouver photographer, took a very personal interest and put an extraordinary effort into the photocopying of the bulk of the artwork for this book. He worked to tight deadlines, charged rock bottom prices, and fussed more than I did. Three other photographers, Ralph Wallis, Robert Wigington, and Joe Salvatti, provided additional copy work for this book. All of them gave me special treatment and for this I am very grateful.

This book has no bibliography, but I would like to mention four authors whose work has been very helpful to me over the years: Eric Arthur; Lambert Florin; Bruce Ramsay, and Eric Sloane. I recommend that you read their books.

Finally, I should thank the folks who built all those great old buildings. They probably didn't know what fine artists they were. Let's be just a little more aware of their work and a little more careful about what we knock down.

Index

There you have it. In this book, I have tried to give you an interesting sampling of the thousands of old buildings we have found scattered across the countryside.

For every side road explored and every building discovered, we have surely bypassed a hundred others. For every painting I have managed to finish, there are dozens I would like to start.

Hopefully, this book will have a sequel. I am starting on it now. Perhaps you could help me. If you know of a great old building somewhere, please let me know about it. Let's record as many of them as we can before they are all gone.

Ronald Woodall
c/o J. J. Douglas Ltd.
1875 Welch Street
North Vancouver, B.C.
V7P 1B7

This book was designed by the author. The text was set in 14 point Goudy Old Style and the headings in Americana by Vancouver Typesetting Co. Ltd. The book was printed by Brock Webber Printing Company by offset lithography. The paper stock is 100 pound Mountie Matte and 80 pound Strathmore Grandee Text, Lugo Grey. The Hunter Rose Company printed the jacket and bound the book using Bayside Linen BSL 655 over 12 point strawboard. The endpapers are 80 pound Strathmore Grandee Text, Basque Brown. Color separation was done by North West Graphics, Limited.